MY BIG BURDISH ADVENTURE

Leni Qinan

ISBN 978-1-291-58565-0

© 2013 Leni Qinan. All rights reserved.

This work is registered in the Madrid Region Copyright Office (Spain) and protected by the EU Directive 2004/48/CE and R.D.L. 1/1996 of 12th April that approves the redrafted text of the Spanish Intellectual Property Law.

The name Leni Qinan™ is a EC Trade Name registered in the Spanish Patent and Trademark Office. The right of Leni Qinan to be identified as the author of this work has been asserted by the author in accordance with the above mentioned rules.

All the characters appearing in this book are real but names have been changed in order to protect the privacy of individuals.

For Richard, wherever he is.

PART 1: PARIS-LONDON

Introduction

Chapter 1:	Jack
Chapter 2:	There's always a reason
Chapter 3:	The Russian roulette
Chapter 4:	Burdishland
Chapter 5:	Tourist class
Chapter 6:	Jimmy the photo-waiter
Chapter 7:	Girly girls' talk
Chapter 8:	Patrick, the ticket office guy
Chapter 9:	The art of stealing souls
Chapter 10:	Eastpac Madrid
Chapter 11:	Eastpac London
Chapter 12:	Lee and the posh boys of the city
Chapter 13:	The noble rot and the huge letdown
Chapter 14:	Way back home
Chapter 15:	The one night stand
Chapter 16:	The morning after
Chapter 17:	The Polish cab driver
Chapter 18:	Leaving London

PART 2: PARIS-LONDON-BRISTOL

Chapter 19: The West Country
Chapter 20: Bristol
Chapter 21: Teach your children well
Chapter 22: A walk to remember (i): The threatening gypsy woman
Chapter 23: A walk to remember (ii): The toothless terrorist
Chapter 24: Guests and fish
Chapter 25: The arrangement
Chapter 26: The plot
Chapter 27: Dinnertime
Chapter 28: The aftermath
Chapter 29: Cinderella at midnight

PART 3: BRISTOL REVISITED

Chapter 30: Two years after
Chapter 31: Welcome to Tijuana
Chapter 32: The mysterious host
Chapter 33: After-dinner convos
Chapter 34: Just you and me
Chapter 35: The Burdish soul
Chapter 36: Theater and tequilas
Chapter 37: The Russian wedding ring
Chapter 38: Leaving Bristol
Chapter 39: Things I've never told you
Chapter 40: I was not supposed to know
Chapter 41: You again
Chapter 42: Gayle
Chapter 43: Mom and dad
Chapter 44: Gayle's secret
Chapter 45: The after-funeral reception
Chapter 46: Untimely, as usual
Chapter 47: Surfing the net
Chapter 48: Splendor in the grass

INTRODUCTION

My big Burdish adventure began in 1991, when I was 22. At that time, I was working as a junior secretary at EastPac's representative office in Madrid. That was my first decent job after two short-term contract positions. At the same time I worked as a freelance music reviewer. I wrote a weekly collaboration for the pop music page of a famous guide to the events in Madrid. Three days a week I taught English to a couple of spoiled kids too. I was in my fourth year of Law School and my jobs helped me pay for my University education.

What you're going to read is not a work of fiction. The story takes the form of a long letter addressed to a man with whom I had a peculiar on-and-off situation that left an indelible mark in my life.

These are my memories of these days and I am the teller of my own story.

BACHELORETTE

"One day, I found a big book buried deep in the ground.
I opened it, but all the pages were blank.
Then, to my surprise, it started writing itself."

Björk Gudmundsdóttir[1] and Sigurjón Birgir Sigurðsson (Sjón)

[1] From her álbum "Homogenic" (1997)

PART 1: PARIS – LONDON – BRISTOL

Chapter 1: Jack

I met Jack in July 1990 at the Banque Paribas office of Porte d'Orléans, in Paris. The old guy looked funny in his beige shorts and black shirt with the message "Don't be tardy for the party" emblazoned on his chest.

He wore a white-socks-and-sandals combination, and that Bristol Rovers' atrocious cap that protected his bald head against the rigors of summer, hiding his white scruffy hair. It was an exceptionally hot day and his cheeks were bright red, as if he had just been slapped. He looked a carnival gone terribly wrong.

I was spending two weeks in Paris with my boyfriend. We worked hard in winter and saved enough money to pay for an Interrail Pass and rent a double room in the very center of the City of Light.

I was withdrawing some money from the ATM inside the office. Meanwhile Jack desperately struggled with the guy behind the counter to exchange his traveler's checks for cash. They didn't understand each other and I couldn't help poking my nose into the conversation. At my very girl scout heart is always the friendly good turn, so I immediately used my language skills to help them.

Some minutes later, happy as a clam with plenty of money in his pockets, Jack invited me to join him for a cappuccino at the Café de Flore.

We chatted for a while and he handed me over a piece of paper where he had written down his personal address and telephone number.

- So you come from Spain, right? –he asked-
- Yes –I answered-
- Thank you for saving this old man from poverty and starvation, senorita.
- It was my pleasure.
- If you ever travel to Bristol, you'll be very well received here. –he said, pointing energetically at the note that he had just written-.

Jack Dawson
65, Filton Avenue
<u>Horfield, BRISTOL BS7 0AQ – (UK)</u>

Then he added his telephone number. His enthusiasm made me smile. To reciprocate, I wrote down on a bar napkin my full name, personal address and phone number and gave it to him too.

- You can call me if you ever visit Spain, or next time you experience a problem with a banking employee, whatever happens first.

Two weeks later, I received a beautiful postcard of the famous Clifton Suspension Bridge, where he had written:

"I made it safe and sound to Bristol. Thank you very much, senorita Martin".

It truly was the beginning of a beautiful friendship. After his trip, Jack told everyone about me. I was known by his relatives, neighbors and acquaintances as "Miss Spain". My good deed for that day in Paris made me a celebrity in the West Country, as I could confirm *in situ* one year later.

Chapter 2: There's always a reason

I first travelled to Burdishland in March, 1991. The official reason for my trip was simply tourism. But the true and main purpose of it was an irrational attempt to meet Lee Anderson, a gorgeous guy I was head over heels besotted with. We were both employed at EastPac –a portmanteau word for Eastern Pacific Bank-. He worked in the London based head office and I did in the Madrid representative office.

Lee was born in Kenya to Burdish parents. His father was a diplomat and he had been sent to boarding school in Kent. He was a snotty rich kid, prepared to become a CEO when he would grow up. He graduated at the London School of Economics and took great pleasure in telling everyone about it. One could recognize him by his bossy expression and his large pectoral muscles. The Spanish managers thought he was the biggest arrogant, annoying, cocky little git. But I found him super cute and irresistible. To be old and wise, you must first have to be young and stupid!

Lee was EastPac's controller for the Madrid office and visited us very often. I was the secretary to the administration manager, and one of my duties was to assist him while he was in Spain.

We were in touch every single day on the phone for work. He was very kind and nice to me and soon started joking with that subtle Burdish irony display. He blinded me with his good manners, his custom-tailored suits and his rugby team scarf.

It only took us a few weeks to go from joking to flirting. It was inevitable. Everybody noticed at work. We were even encouraged to go on. I was the youngest person in the office and all my workmates considered this puppy love a breath of fresh air that broke their everyday boring routine. Unfortunately, some signs led me to think in error that the feeling was mutual.

A couple of months later I was totally crushing on him and carried away by a bad case of toxic infatuation. As he wouldn't make a move, one fine day I had this great idea: I would take some days off, fly to London for the first time in my life and "incidentally" meet him. A visit to Jack Dawson was included in my travel plan as well, but if things with Lee worked out as I expected, that one would be expendable.

Chapter 3: The Russian roulette

Maybe I sound too dramatic if I confess that to me, flying a plane is like playing Russian roulette. In my opinion, the well-known benefits of air transport are unavoidably linked to this terrible uncertainty: you may crash or you may not.

I know the stats confirm that flying is the safest way to travel; but whenever I do, I have the horrible feeling that the more I fly, the higher my chances of crashing will be. A loose screw, a fatal lack of fuel, a lightning striking the aircraft or a wing falling off, a stroke of bad luck and... boom! You're gone forever. And it's all beyond your control. It's just a matter of probability.

Yet for some years I had to fly quite often for work and believe it or not, I even had a frequent flyer card. So what did I do when I had to take a long distance flight? As soon as the plane took off, I ordered two drinks (enough to raise my blood alcohol level up to moderate intoxication phase and keep me totally out of it for several hours) and gulped them down. Then, I listened to some chill-out music in my walkman to help my alcopops work better and repeated the procedure as many times as necessary. Because if I was supposed to crash... I didn't really need to know in advance.

As time went on, it became clear to me that I needed a better solution to combat my fear of flying or I would end up as an alcoholic. So I had a friendly chat with my general practitioner and told her what my problem was.

She gave me a speech about phobias and therapies. She said it was strongly recommended that passengers suffering with fear of flying attended the "Flying Without Fear" days organised by the airlines operating at the Madrid airport. Otherwise I would spend the trip with my nose in a bag, looking like a moron and shouting "We're all gonna die!", while the crew would politely threaten to pitch me out over the ocean if I didn't behave myself.

- That's fine doc, but in the meantime I need an emergency solution. -I said-

The nice lady doctor, who I presume was probably affected by the same problem as well, prescribed me a tranquilizer that could have knocked-out a gorilla.

In fact, as soon as I took off on the JK 3537 Spanair flight Madrid-London I experienced an intense feeling of sleepiness for about two hours; almost the time it took the aircraft to take off from Madrid and safely land at the Gatwick airport.

Chapter 4: Burdishland

Since we met, there are a few things I've never told you but always wanted you to know. One of them is I really like your country. I've lived there amazing adventures that made me feel like Alice in a Wonderland that changed the course of my existence. Perhaps that persistent rain or the cold winds made me say and do things that no one would expect from me at home. The truth is that as soon as I set foot on Burdishland I became an unpredictable creature and got involved in the most surreal experiences.

The first memory of my big Burdish adventure is a number of aircrafts perfectly lined up waiting on a runway at Gatwick airport. All of them had the silhouette of a naked maid painted in red on the tail. The weather was cold but very sunny. The wind was blowing through my hair and my senses woke up from the long sleep produced by the tranquilizers.

The first person I spoke to in England was a young policeman at the airport passport control. I gave him my Spanish pass. He had a look at my picture, stared at me and made a joke:

- Hmm… So senorita Anna Martin from Madrid, right?
- Yes.
- Are you travelling for tourism or for matrimony?
- For tourism! –I answered, very embarrassed-

After my first encounter with Burdish humor —that I obviously didn't appreciate- I recovered my passport and collected my trolley at the baggage reclaim. As I walked to the exit door, a rookie customs official asked me:

- Can you come with me please, madam?

I wasn't aware yet, but I had been awarded with a selective check on my luggage. Meanwhile, the passengers of my flight walked rapidly in the opposite direction to avoid him, just in case there was a second prize winner.

- Do you have anything to declare? —he asked me-
- No —I said, smiling and hoping he would be fast-
- No tobacco? Spirits?
- No, sir. —I answered, still smiling-
- Are you carrying drugs?
- Of course, NOT. —I said very upset, as I stopped smiling-
- Do you have any weapons? Any liquids?
- God, NO! — I shouted, very offended-

He registered my clothes and had a thorough look at my undies. I asked myself what on earth he was expecting to find there. I saw myself confined and imprisoned at some sort of Burdish Guantanamo for the rest of my life.

- What is this? —he asked, shaking a small round red box that sounded like a rattlesnake.
- It's liquorice candy, not black cocaine. Would you like to have some? —I asked cheekily-
- No thanks.
- Is there anything else you would like to register, sir? —I asked-
- Yes madam. —he answered-

Bloody hell…

- May I have a look at your handbag, please?

I gave it to him and sat on the floor beside my trolley, which was still open, showing shamelessly to the passers-by all the cheekinis and waist cinchers embroidered in red lace and silk that I had carefully prepared to bewitch the gorgeous Lee Anderson at our very much desired orgy.

- Can I pack my things now, sir? —I asked, as I started putting the sexy stuff back inside the trolley.-
- Yes, of course. —he answered-

Then and only then, he stuck the green-edged label on my baggage and set me free.

Chapter 5: Tourist class

Getting up in Madrid at the crack of dawn, suffering with intense fear of flying through the air space of Spain, France and England for nearly 3 hours under the effects of a sleeping-pill, experiencing an ordeal at the Gatwick customs office and dragging my luggage through airports, onto buses, along miles of escalators and tube station corridors all over London had left me knackered. And on top of that, I was starving.

I was really on my last legs when I checked in at the hotel, exactly at 1 p.m. I was booked at the Blickwood, a four-star decadent building located in Russell Square, in the very center of London.

- Good morning. My name is Anna Martin. I have booked a single room for five days. –I said–

Everything seemed to be in order: vouchers, passport and booking. The woman gave me the key to room 418.

- Thank you. Could you tell me where the elevator is, please? –I asked–

She stared at me.

- The LIFT is over there —she answered, pronouncing every word very slowly and pointing at right–

I didn't like the lady's veiled mockery about my slightly americanized accent and vocabulary. Least of all the way she emphasized the Burdish word and her subliminal message about what was correct and what wasn't. So I stared at her for some seconds.

- Thank you very much for telling me where the ELEVATOR is, madam. —I said, ironically-

She probably thought I spoke like a chipmunk. And she was right: my vocabulary is contaminated by loads of Connetticuteries, Wisconsinities, Mississippitties and other idiomatic impurities unrelated to the Burdish Islands.

I started learning Burdish at school when I was 12 years old. My teachers were from La Jowlla, Calefornia and Uston, Texuz. I was an excellent student and as it is well known, everything is contagious but beauty, including the accent. This is the reason why I muddle through my Burdish, but not through the Oxford clear and precise diction. And I'm damn proud of my accent!

But that day I was not really in the mood for a lecture on orthodox Burdish.

Jack used to joke a lot about my Yankee accent.
- Don't say "Burdish", say British.
- Burdish —I'd go- That one's very difficult. Let's try something easier.
- Ok ok. Don't say "y'all" but "you all".

- Y'all. –I laughed- No, I just can't.
- Come on, Annie. You sound like a bloody cowgirl! Instead of saying "stoo" and "noo", say "stew" and "new". –he said-
- Stew, new –I said, forcing a perfect Burdish accent, raising my pinky while drinking tea.-
- Perfect. Maybe in 10 or 20 years you'll sound a bit British.

That game really made me laugh.

Room 418, my room, was small and made of ticky-tacky. It didn't match the hotel's majestic façade. And it didn't look remotely like the pictures that the travel agent had showed me in Madrid. It was very apparent that the management intended to save money, because the whole building needed an urgent refurbishment. I guess that, among other things, that was what "tourist class" meant.

Anyway, I didn't care too much about the dusty maroon velvet curtains or the black stains on the flashy carpet, because I had to phone Lee Anderson immediately and nothing else mattered to me at that moment. I dialed his number and he answered the phone.

- Lee Anderson speaking.
- Hi Lee, it's me! –I said, totally ecstatic and hoping he would recognize my voice-.
- Annie? Where are you?
- In London. I've just landed.

Of course, I had announced my trip beforehand with much fanfare.

- Did you have a nice flight? —he asked-
- A bit bumpy, but I made it safe and sound.
- That's cool. Would you like to meet up?
- Sure.
- What about tomorrow afternoon at the Bank? We could meet at Athena's House at 1 p.m. if that's ok with you.
- That's fine with me.
- I'll show you the office, introduce you to some colleagues and then we could have a snack and some beers at The Anchor.
- Lovely, I'll be there.
- Great, see you tomorrow then.
- Ok, bye bye Lee.
- Bye bye Annie.

His lovely accent… his deep manly voice… he had a hypnotic effect on me. I was so excited about meeting him that my panties were wet when I put the telephone down.

Chapter 6: Jimmy the photo-waiter

During my big Burdish adventure I met a few people. Some were very nice while others not so much. Jimmy was among these last ones.

When I arrived to the Blickwood Hotel it was long past Burdish lunchtime. It was even late for Spanish lunch. My stomach started growling so loud that I left my luggage in the room and immediately rushed downstairs to the hotel cafeteria. There I came across a most peculiar individual: a cheeky, cunning, attractive trickster that worked as a waiter at the hotel bar. He was a very tall and thin. He had a little soul patch under his bottom lip and looked real good in his black outfit.

- Can I get you something to drink, madam? –he asked me-
- Yes, please. I'd like to have a cup of coffee and a salmon sandwich too, if possible.
- Sure. That comes with either fries or a baked potato. Which would you prefer?
- With fries, please.
- Sure.

Five minutes later, the guy was back with my lunch. The way I gobbled it up, you would think I hadn't eaten for days. The waiter kept an eye on me while he worked behind the counter. As soon as I finished the sandwich, he rushed back to my table.

- How was everything? – he asked me very nicely-
- It was delicious.
- Can I get you anything else?
- No thanks, that's all.
- Are you staying at the hotel?
- Yes.
- May I have your room number to charge it to the bill, please?
- Yes, 418.

He noted it down. As he was clearing the table, he got closer to me and asked softly:

- Are you staying here for very long?
- Five days. –I answered-
- Your English is brilliant, but there's a very slight accent I cannot identify. You're a non-native speaker, aren't you?
- That's right.
- Where do you come from, if I may ask?
- Spain.
- Oh, I should have guessed it from your beautiful black eyes! Like that song that goes… "our love shines like rain in those Spanish eyes[2]"… -he sang-
- Thanks –I said, praying that he wouldn't continue singing-
- Did you know the song? -he asked-

[2] From U2 "Spanish eyes"

- Yes. –I answered, very embarrassed-
- I bet you have to hear it several times a day from your devoted admirers!

I forced a smile, feeling very uncomfortable. Something was rotten in the state of Denmark. I asked myself what did he want from me and how long would it take him to say it. I couldn't help showing passive hostility. I was ready to go on the defensive.

- I'd like to ask you something… do you like photography?-he asked-
- Very much.
- I'm a free lance photographer.
- Really? And what is your specialty?
- I do books for models.
- That's very interesting.
- Yeah, I really like doing that. Have you ever been at a photo session?
- No. I'm not a model. –I answered-
- You could very well be one. You have a really pretty face and a very good figure.
- Thank you for the compliment.
- Really, I'd like to take some pictures of you in my studio, if you don't mind. –said the spider to the fly-.

As you must have guessed, it wasn't exactly my pretty face what he intended to photograph. In addition to it, at the height of generosity, I had given him my hotel room number.

He stared at me, waiting for an answer. I tried to skirt around the question to politely let him know that I was not interested in a porn photo session.

- No hurry. Take your time to decide. –he said-
- Sure. –I replied, vaguely-
- My name is Jimmy.
- Nice to meet you, Jimmy. I'm... Martha. –I lied-.

We shook hands.

- You'll find me here every day from 9 to 5, except on the weekends.

"Dream on" –I thought-

- See you sometime, then. I must be going now. –I said-
- See you soon, Martha.

I turned on my heel and got the hell out of there. I'm no prude but I hate being fooled. Needless to say, I avoided the Blickwood Hotel cafeteria for the rest of my trip.

Chapter 7: Girly girls' talk

The first night I spent in London I slept like a baby, which was not surprising, after an exciting day filled with so many novelties.

The morning after my arrival I had breakfast at the "Salon Doré", the hotel dining room. I sat at the last free table. I was having a toast and coffee when an outstanding beautiful blonde entered the room. I thought chivalry had definitely died in London, because every man there stared at her more than it was polite and proper to do so, but no one offered her a seat. She walked across the dining room, approached me and asked:

- Do you mind if I take this seat?
- No. Please. —I said, inviting her to join me-

She had a perfect face, big blue eyes, long shiny blond hair and a wonderful smile.

- My name is Sophie. —she said-
- Pleased to meet you Sophie. I'm Anna. You're not Burdish, are you? —I asked-
- No. I come from Geneva, in Switzerland. And you?
- Alors… tu parle français[3]
- Bien sûr![4]

[3] "Then you speak French"

We immediately switched to French. The change gave us some privacy.

- I'm Spanish. I'm here on holidays. –I said-
- Lucky you, I'm here for work. –she replied-
- I hope you have some time to visit London. It's really a beautiful city.
- I may stay here for the weekend.
- That's great. Are you on your own?
- Yes, and you?
- I'm alone too.
- How come? Don't you have a boyfriend to travel with? –she asked, smiling-
- We broke up some months ago.
- I'm sorry to hear that.
- No worries, I'm much better off without him. And you, do you have a boyfriend?
- Not now. I'm free since last week.
- Don't say it too loudly or you'll have to beat them off with your umbrella –I said pointing at the male audience present in the dining room-.

My trip was meant to be an odyssey to help me get rid –among other awkward feelings- of my post breakout loneliness.

[4] "Of course!"

As far as Sophie was concerned, she didn't look very sad about her split. She was hearty and extroverted. It felt fine to be talking so freely. After our second coffee, our conversation became a very interesting girly girls' chat.

- What do you think about British men? -she asked-
- In my country they say they're reserved and cold with foreigners. – I answered-
- I'm more interested in your own opinion. Do you believe British men are a mixture of James Bond and Hugh Grant?
- As far as I know, James Bond was half Scottish.
- You're being very elusive.
- I think they're witty and charming, but emotionally constipated. They aren't normally demonstrative and as far as I'm concerned, it's hard to know what they think or feel. But that's just the stereotype I have in my mind. And you, Sophie, what's your opinion about them? –I asked her-
- I think British men are polite but too shy and excruciatingly slow.- she answered-
- Slow for what? –I asked-.
- For flirting.

That worried me a bit because I was short of time with Lee and I expected him to be very daring.

- Perhaps you fancied a Burdish guy and he was taking his time to let you know that he felt the same for you? – I asked–
- No.
- Then, how do you know they're slow to start a relationship?
- From empirical observation.
- Did it happen to a friend of yours or to one of your colleagues at work?
- To a friend.
- You mean you're judging an entire country off one person that a friend of yours met?

She stood quiet and stared at me.

- If a British guy is interested in you and you ask him out, he will run a mile. He may be drooling over you for months but if you pull your clothes off he will speed away, unless he's drunk as a skunk. -she said, ignoring my previous comment-

I didn't know it yet, but during my big Burdish adventure, I would go myself through that situation with deplorable consequences.

- It's not in their culture to be emotionally open. If you do that, you'll scare guys away, wherever they come from. –I said, pointing at her-

She giggled.

- Not everything is black or white, Sophie. I'm afraid you're being a little bit unfair. There must be some exceptions to your rule. Otherwise the human race would be extinguished in Burdishland. —I said—

We laughed again.

- Maybe they just need a little push and a huge green light to go ahead, so be patient and try to show your Burdish suitors the way. —I added—

We kissed goodbye and promised to write a postcard telling each other about our experiences.

- Au revoir ma biche, et bonne chasse chez les goddamms![5] —she said—

At that very moment I disagreed with Sophie's stereotypes and national jokes. But the future would confirm that there was an element of truth in her anthropological theories about Burdish men.

[5] Goodbye sweetie, and good hunt at the"goddams"!

Chapter 8: Patrick, the ticket office guy

One of the things I have always wanted to do in London but never could was watching a theater play or a musical. Home and abroad I had read excellent reviews about "The phantom of the opera" and was very excited about watching it.

- I'm sorry, but there are no tickets available until next month. - said the guy at the hotel booking information desk-. We may have some cancellations for "Les Misérables", "My girl", "A chorus line" and "Saigon bride".
- Ok "Les Misérables", then.
- When would you like to see it, Miss Martin?
- On Saturday.
- And how many tickets would you like to book?
- One.
- Only one? —he looked at me as if I had two heads-

Once again I was unveiling an important piece of information about me to a total stranger.

- Yes, only one. —I answered, very embarrassed-
- Here's my business card and this is my telephone number. Please phone me around 1 p.m. and I will check with the theatre if there are any cancellations.

BLICKWOOD HOTEL
Patrick McLachlan
Assistant Manager
Booking information and ticket office
Tel No: XXXXXXX

Do you remember the days when science fiction uncannily predicted the digital era? Can you think of a world without smartphones, Whatsapp, touchscreens, laptops, iPods/iPads/iPhones, websites and e-mails? That was exactly the scenery of my big Burdish adventure: the analogue world. The most modern device I owned in 1991 was my walkman, that worked with 3 x 1,5 volt batteries. I could either listen to my favorite radio stations or to a cassette tape recorded from my preferred vinyls.

At EastPac my main working tool was a 386 SX IBM PC (the jewel of 1991's avant-garde computing) that ran with MS-DOS 3.2, the old Word Perfect, the prehistoric Lotus 1-2-3 for spreadsheets, some in-house applications and other relics of the past. That was all and it was the best of the best.

So in these old days when mobile phones didn't exist yet, Mr. McLachlan kept me phoning him all day long, from a phone box at Victoria Station, from a bar pay phone near London Bridge and later from Trafalgar Square, until I got tired of always asking him the same question and always getting the same answer:

- Unfortunately there are no cancellations for "Les Misérables". – were his last words-

So I decided to forget about the theater. But that wouldn't be the last time we'd speak.

Chapter 9: The art of stealing souls

Friday was the D-day and 1 p.m. was the H-hour. I had a premeditated plan to launch my offensive against Lee Anderson in the afternoon.

Early in the morning I had a walk from the hotel to the Burdish Museum and sat on a bench in the sun at Russell Square. Some minutes relaxing there made me reach an incredible sense of wellbeing. As I was peacefully enjoying these moments, my harmonic meditation was interrupted by the sight of a young couple. The two of them carried small backpacks with the Australian flag on top and flung themselves into the bench that was right in front of me.

The guy took a charcoal pencil and a sketch-pad from his backpack. He studied visually the surroundings very carefully. Then he stared at me from the distance and whispered something to the girl. For five minutes, the street draughtsman quietly measured up with his pencil imaginary distances to outline what seemed to be a sketch of me while I pretended I was not looking. But I was.

The guy was drawing me without my consent. I felt as if he would be capturing a part of my living essence, taking advantage of my unawareness. I was upset to feel a tiny piece of my soul fly away and uncertain about the right over my own image. Was I still under the influence of the photo-waiter's malicious offer? I got up and left. The street draughtsman followed me with his eyes as he drew as fast as he could, until I disappeared into the Museum's ticket office.

Chapter 10: Eastpac Madrid

EastPac Madrid was based in the financial center of the city, in the heart of an expensive neighborhood. It was a small representative office, not an operational branch, and we were only five employees: three managers and two assistants, Jill and me.

Jill was the general manager's personal assistant. She was a very nice Dubliner in her late fifties, who took Spanish citizenship after living in Spain for more than 30 years. She taught me everything about work and also very useful stuff about men and life in general.

The main task of the three bosses was to spot business opportunities in Spain, basically corporate loans, and report directly to the London management.

Our office was a nice 5-room flat located in a residential building. The good thing about it was the great working atmosphere. The bad thing was that there were some minor inconveniences that didn't offer a very professional image of our premises to the Burdish executives.

Some examples of the situations that they most disliked were the following:

1. Food smell: Every day around 2 o'clock –standard Spanish lunchtime- the whole office started smelling of food, so we knew exactly what the midday meal menu of the front door neighbors was. Mostly, anything with garlic.

2. Noisy kids next door: About closing time, we often heard them play and laugh when they came back from school. We were used to it, but whenever some big shot from London was around, we were given very specific instructions: the windows always had to be kept closed, to reduce the noise coming from outside.
3. Untimely appearances: The porter's wife was in charge of the office cleaning. She would break into the office at five sharp with the vacuum cleaner on at maximum power and start hoovering up the conference room, even if there was a papal conclave about to decide. One of my most important duties was to ask her nicely, so that she wouldn't take offence:

- Rosa, would you please be so kind to start cleaning up the filing room? The managers are about to finish here. Thank you very much, indeed.

Around 3 p.m. I used to have a microwave heated late lunch at the office kitchen with Jill. She always had half a can of Heinz baked beans, because —in her own words- she was too lazy to cook. It was in these small moments when Jill offered me her most valuable piece of advice:

- Give him a big smile and flatter him as much as you can. This is what men love most, apart from sex. If you do it right, he will do the rest. —she said, referring to Lee-.

Chapter 11: Eastpac London

Madrid representative office and EastPac London didn't look remotely alike. London branch was EastPac's European Headquarters and the rest of offices in Europe (Milan, Athens, Zurich, Frankfurt and the Channel Islands) reported to them.

The main office was composed of two buildings —Athena's and Palace House- placed alongside each other and communicated through an elevated covered bridgeway at the tenth floor level. Approximately eight hundred employees worked there. These two wonderful skyscrapers shaped in the most modern architectural designs were built in the very heart of the City during the late 80s with amazing views over the Thames, beside Southwark Cathedral and right opposite to Cannon Street Station.

Athena and Palace House had twin marble reception counters. Behind them, two nice girls greeted the visitors and three switchboard operators answered the incoming calls. There were also two huge security guys that looked like ninja turtles guarding the front gate. The employees had lunch at the bank canteen in the ground floor. Everybody complained about the food but in all honesty, it wasn't that bad.

I found out in the internet that after drastic staff cuts during the 90s, EastPac moved from their corporate buildings to smaller and posher premises at 140 Bank Street, in the Canary Wharf business district.

At 1 P.M. sharp I was waiting at Athena's House's reception desk. I said to one of the receptionists that Mr. Lee Anderson, from the Corporate Banking Department, was waiting for me. She phoned him and he came downstairs to fetch me.

It took him just a couple of minutes, but it seemed like an eternity to me. But there he was: mousy-haired, green-eyed, pale as snow… and drop-dead gorgeous! My heart fluttered like a popcorn machine.

- Hey Annie!
- Lee!
- You look really good!
- Thank you! You look great too! It's so nice to see you again!

We approached each other shyly. Would he grip my hand before I was all the way into the grab? Would he just air-kiss me and do the "mwah" sound? I guess he was asking himself the same questions, because we met halfway, not knowing what was the right thing to do. I took the initiative placing my right hand on his left shoulder as a warm-up. Then I shot him a magic, contagious, broad smile and shook my head so that my pigtail wobbled and softly pressed my lips against his cheek. He didn't expect that and wore a happy surprised smile for a while.

Chapter 12: Lee and the posh boys of the city

We went upstairs. He wanted to show me the premises. The doors had high security locks that could only be opened with a magnetic card, so every now and then we had to stop in the long corridors.

- After you —said the perfect gentleman, opening all doors for me-

It took us a little while to get to his office. People looked at me from the other side of the glass walls and smirked while he made a vain display of himself walking me all over the place, as if I were his last conquest. It was very apparent that he wanted everybody to see me with him, but he acted as though he wouldn't take any notice.

When we left the building it was raining. I opened my umbrella and we walked together.

- I need to go to the ATM because I'll be spending a lot of money this evening. Do you mind joining me? – he asked-

He said that deliberately, expecting my question.

- No, I'll join you. But may I first ask why are you going to spend a lot of money this evening? —I asked-
- Because I'm going to drink a lot.
- Oh. —I said, shocked and very disappointed-

I realised that he had a demanding job. I knew that he worked like a dog every single day. I could see that he was stressed and needed an escape mechanism. But being the daughter of an alcoholic father who had decided to drink himself to death after many failed attempts of detox and rehab, I could hardly understand why someone would want to pay so much to get drunk as hell.

- When my friends see me with such an attractive woman they will think I'm a very naughty boy!

What a lousy answer! I wondered if he had already started drinking, because I didn't understand what he was trying to tell me.

- You mean... me? –I asked, pointing at my face-
- That's right –he answered, blushing-
- Well... thanks for the compliment, Lee. But still I don't get why they would think you're naughty.
- Because my girlfriend is on holidays.

I remained frozen in shock. If he had a girlfriend, why was he flirting with me? Was she on holidays and he was not with her? What kind of crappy boyfriend was he? I was not the person to judge him, but this new turn annoyed me big time. We were having a very bad start.

However, not everything was lost.

He didn't seem to care too much about his girlfriend, which was good for me, so we could still have some fun and enjoy a night of good sex, if only he didn't drink too much. And then… each for himself and God for us all.

We went to the ATM and then to The Anchor, one of the oldest pubs in London. I didn't know that London's history could be measured in the age of its pubs. I was amazed to hear from Lee that some of them dated back to the early fourteenth century. It was amazing to think that I was at the same pub where the crème de la crème of the Burdish writers (Charles Dickens, Robert Louis Stevenson, Mary Shelley, Lord Byron and the very same William Shakespeare) used to drink and have a social life.

The Anchor, at 34 Park Street, was a very picturesque historic pub on the south bank of the Thames. It has several bars, a restaurant and roof terrace, both of which have wonderful views across the Thames to the City, and a large seated area on the riverbank. It was packed with hungry office workers. I ordered a coke.

- You may prefer a glass of wine. –said Lee-
- Not really. I'm not much of a drinker, but thank you just the same.

As a matter of fact, I can't even stand the smell of alcohol or tobacco on the breath. People often laugh at me because I neither drink nor smoke. I don't care now, but that worried me when I was young.

- Start laughing at them when they're dead —said my temperamental mother-

When I was at college my friends used to smoke pot on a regular basis. They were very generous: I was always asked to share it with them and occasionally took a drag of a joint. I can't say I enjoyed the weed experience much, so I quitted. Right after that I was the butt of every joke told when we met and I started hating them.

Everything they did was irritating to me: their giggles all day for no reason; their red, bloodshot eyes; their rushes downtown to the Chinese street stalls late at night to buy junk food to calm down their munchies. They also snorted cocaine from time to time. I was always kindly offered a line, but never accepted. I was labeled a chicken-hearted softie. Their sudden artificial overexcitement, extreme euphoria and verbal diarrhea made me feel uncomfortable. I really felt uneasy and totally out of place because of the group pressure. It was hard to be assertive and confront the coercive persuasion of these guys. But I never did anything I didn't want to do.

Lee found a small place for us at The Anchor. We were real close to each other and from time to time, he was inadvertently pushed by passers-by against the wall I was leaning on.

- Oops, sorry —he repeated every time he bumped into me- This place is very busy on Friday afternoons.
- No worries. — I said-

"Push me hard against the wall and kiss me deep". –yelled my inner voice-

But he didn't seem to be listening. A disturbance in the pub distracted my attention: somebody crashed into a waiter and his tray of drinks went flying right beside us.

- Are you okay, Annie? –he asked-
- I'm fine, thanks –I answered-

"Come on, squash me, silly, can't you see that I want you badly?" –yelled again my inner voice again as I looked into his eyes-

But apparently, he was deaf, immune to my feminine wiles, hadn't drunk enough yet or simply was too lazy to make any move. Whatever it was, in spite of my subtle invitations to invade the boundaries of my personal space, he observed a polite distance. So for the moment, I looked around in search for other, more mundane matters, for instance the menu of the day (which was composed of steak pie and Yorkshire pudding, to choose one).

- What's this Lee? –I asked, pointing at two small trays on the counter-
- Pickles. And that over there is horseradish. – he answered-

There were also some snacks: fries, olives and pork scratchings. I couldn't eat anything because I wasn't really hungry. Being overexcited to see him again and troubled by our previous conversation didn't help: I had a nervous stomach.

But before I'd feel weak and my body would desperately ask for food, I took a nibble from my steak pie.

Lee waved hello at two young guys that were sitting a bit farther from us. One of them waved back and made a sign asking us to join them.

- Hi mates! —he said-
- Hi!

What followed then could have been excellent material for a TV documentary about the social behaviour of primates. Alpha male defended his ranking from two beta males:

- Let me introduce you to Miss Anna Martin. She works at the EastPac rep Office in Madrid. —said Lee to the guys-

We shook hands while beta male 1 gave a verbose introduction of himself:

- I'm David Jones, from the Treasury Department. I work as a team leader of EastPac London with a 20-accounts portfolio. —he said arrogantly-
- Nice to meet you, David. I'm pretty sure that EastPac would love to recruit some more like you. —I said-
- You can call me Dave.
- Ok Dave.

His beta 2 buddy didn't want to be left behind and boasted about his professional accomplishments as well:

- Pleased to meet you. I'm this team leader's boss. –he said, looking at Dave-. I run a 52-corporate accounts portfolio. My name is Jeffrey Blake but you can call me Jeff, Annie.
- Uh Oh! No one calls her Annie but me, ok? –interrupted Lee, as if I were his own property-

The alpha male finally imposed himself on the two betas. We all laughed, but Dave and Jeff didn't leave the table, which made Lee feel quite uncomfortable, because he expected us to have a bit of privacy.

The two guys basically spoke about themselves: how talented they were, how many countries they had visited, how many languages they could speak, how important their prospects in the bank were and how senior they were likely to become in the short term.

- Do you know polo? –asked me beta 1-

"Yeah, that sport played in those preppy Ralph Lauren TV commercials." –I thought-

- No –I lied, just to make him talk-
- It's a game similar to field hockey but played on horseback using long-handled mallets and a wooden ball. Polo is a game of skill and patience. –he said very solemnly, as the other two nodded-.

And a game of money, I would add.

- It's definitely getting more popular nowadays. –said Lee-
- Indeed, it's incredibly accessible now!– added beta 2-

Of course, commoners should not be allowed to rub shoulders with those who play the sport of kings.

- I prefer country sports like archery or falconery. –said Lee-

I was getting tired of these guys bragging about their intellectual, physical and social skills. They were too posh for my taste

- It's almost 3 o'clock. Shouldn't you go back to work, guys? –said Lee-
- Oh.
- Could I have a private conversation with the lady? Your presence is no longer required here –asked Lee-.

They complained, laughed and finally left.

- Annie, would you like to meet up this evening at a pub called "The Noble Rot", near Chancery Lane? –he asked me-
- Sure –I answered, hardly concealing my excitement-
- Some friends of mine will be there too. We're meeting at 6 p.m.
- That's cool.
- Do you have a map? I'll show you how to get there.

- Yes, of course.

I took my pocket map of London and he looked for the meeting point.

- I may be a bit late, but my friends will be there.
- But ... how will I find them? I don't know them -I said, a bit disappointed-
- Don't worry, they will recognize you and speak to you. -he said as he painted a big red dot on the map, right on the place where the Noble Rot was supposed to be-

Wasn't it rather strange to announce that he would be late and ask me to join his friends, who had never seen me and whom I didn't know? Was he going to give them a detailed description of me? Would I have to ask every group of people in The Noble Rot if they knew him?

I didn't expect him to pick me up at the hotel in a white limo with wine and flowers, but I smelled a rat.

Was he trying to discourage me or get rid of me with such a crappy plan? I feared we were losing our momentum.

Despite of all this I didn't dare to object. I had flown to London to see him, so at 6 p.m. sharp I would find him and/or his friends at The Noble Rot. It was decided.

Chapter 13: The huge letdown

Jeez, that was promising. I headed to the tube, dressed up to the nines. My destination: Central Line, Chancery Lane. But... how scatterbrained I can be sometimes: did he say "The Simple Knot"? "The Double Spot"? "The Triple Shot"? "The Smoking Pot"? Oh no, it was "THE NOBLE ROT".

I had left my London map at the hotel. So what? Why would I need it for? My photographic memory would help me remember the way from the tube station to the pub. I was clever enough to find the meeting point immediately. No problemo!

I walked several blocks down High Holborn for half an hour, but to my utter despair, The Noble Rot seemed to have been mysteriously swallowed by a supermassive black hole.

It was pretty gloomy, dark and rainy too. I was completely lost and desperate enough to ask for directions but unfortunately, there was nobody around. The whole area was deserted, as if a neutron bomb had hit it. I kept walking five more minutes until I found a trace of Burdish life on my way: a bewhiskered newspaper stand vendor about to go home.

- Excuse me sir, do you know a pub around here called "The Noble Rot"?
- No –he said confidently-

I watched his big bushy moustache move up and down as he chewed his bubble gum.

- Are you sure? –I asked-
- Absolutely. I've been selling newspapers here for more than ten years and never heard of such a place. But if you help me with the cash, I'll help you with the pub. Open your hands, please.

Before I could even answer, he put two heavy plastic bags full of coins on the palms of my hands. The situation was becoming surreal.

- You seem a decent person and I don't expect you to rob me what I've earned today. –he said, staring at me-
- I wouldn't rob you sir, even if I could. You must have made plenty of money today, because I'm stuck on the ground. These bags are heavy.
- If I were a rich man, yubby-dibby-dibby-dibby-dibby-dibby-dibby-dum! All day long I'd biddy-biddy-bum, if I were a wealthy man! – he sang loud- Yay! If I were a rich man, yubby-dibby-dibby-dibby-dibby-dibby-dibby-dum…
- Excuse me for interrupting your beautiful chant, but I insist: these bags are heavy. –I said bending over-.
- I'm done, young lady.

He took the bags I was holding, closed the newsstand and said, pointing at a distant neon light:

- Over there.

He took me to a pub called "The Miser's Plot", a name with a surprisingly similar phonetics to "The Noble Rot".

Then, he waved goodbye saying he would be glad to stay, but was in a hurry.
- The wife ... you know. —he added, waving goodbye-

Before the guy regretted leaving and decided to come back and join me I went into "The Miser's Plot", driven by an irrational force. It was probably a hundred miles away from "The Noble Rot", but I was bound and determined to find Lee Anderson & friends, although it was neither the right place nor the right time to do so.

I had a careful look inside but, of course, he was not there. Yet, I continued my incomprehensible, inconsistent and stupid search. I went downstairs to the cellar but there was no trace of him there either. What about his buddies? I approached all the groups, interrupted their conversations and asked them:
- I'm looking for a guy called Lee Anderson. Are you his friends?

All of them looked at me as if I were insane and answered: "No". I felt really pathetic. But far from being discouraged, I spoke to one of the waitresses:
- I'm looking for a guy called Lee Anderson. Have you seen him?
- Can you describe him? —she asked-
- He's tall, mousy, has green eyes ... and probably wears a blue jacket and tie.
- Well ... they all look the same —she said laughing and pointing at the crowd-

I had a look around and saw how right she was. All the guys in the pub were London office workers having a drink on Friday evening. All of them wore dark jackets and ties because they hadn't changed their business clothes; most of them were tall; and who the hell cared about the colour of their hair and eyes?

I had almost lost all hope when I made my last attempt at the guy who was sitting next to me.

- Hi –I said, smiling-
- Hi –he answered-
- I suppose you don't know Lee Anderson, do you? –I asked
- Should I?
- No.
- Are you waiting for him?
- Yes.
- Perhaps he's late.
- Two hours?
- I think he dumped you. –he said, as he swivelled his stool round to face me-.

It was not the right moment to flirt with a stranger. All of a sudden, I had a bright idea: I jumped down off the stool and asked the girl behind the counter for a telephone guide. I looked for The Noble Rot and dialled the number.

- - I need to speak to a guy called Lee Anderson. He is there with a group of people since 6 o'clock, more or less.

- Could you trace him for me, please? – I asked-

I was on the edge of giving up and she was my last resort. My tone of voice was so sad and tired that I suppose she felt sympathy for me. That was probably the reason why she looked for him and we could talk. Lee said he and his friends had been waiting for me at The Noble Rot since 6 p.m., but they thought that I had changed my mind about going and finally decided not to accept their invitation.

They were about to leave.
He was so tired.
What a shame I misunderstood him.
What a pity I was lost.

- Come on, it's not so late! Wouldn't you like to have a drink in... say half an hour? –I asked-
- I'm sorry but I can't. My girlfriend is back and I have to meet her at 9 p.m. –he answered-

And yet I asked for a second chance. What was I, deaf or stupid? Maybe we could meet up some other day. Perhaps he could spare me some minutes on Monday and have a coffee together...
- I'm sorry Annie -he said-. On working days I'm really busy and I don't even have a minute at lunchtime because I play squash at the gym.

His answer finished me off. I wasn't even worth a squash match.

I finally got the message and put the phone down. The abrupt return to reality left me punch-drunk. My brain couldn't process the disaster and I had to go slowly through all of the steps to realise what had just happened.

Chapter 14: Way back home

Lee had stood me up. His girlfriend was unexpectedly back in town and he had to clock in at home by 9 p.m. That meant our date had been suddenly cancelled without prior notice. I got my hair and nails done, shaved my legs, and put my best dress on for nothing?

Yes, he stood me up and left me to wander alone in the dark streets of London under the rain, all dolled up and ready for the runway. To hell with everything.

I stopped at a zebra crossing and just watched the cars whizz on by. I had no umbrella and in a matter of seconds I was drenched in the middle of the street, wondering which direction I should take to the nearest tube station. I was so dazed and confused that didn't notice the "Look Left" sign painted in white letters on the road surface to stop foreigners from getting creamed by large trucks and buses as they crossed looking the wrong way, which is the right way for continentals. I was about to cross when a speeding bus honked its horn in my ear, belched a cloud of smoke and nearly rammed into me. An old man behind me strongly grabbed my arm and pulled me back fast enough to prevent me from getting crushed. I had the freight of my life. My heart was beating like a drum. I felt like crying.

The old man stopped beside me. He saved me from a serious accident.

- Are you ok, young lady?

- Yes, sir. Thank you very much. If not for you, I could have been badly hurt. I was distracted. Excuse me, would you be so kind as to tell me where's the nearest tube station, please? –I asked-
- Just in front, Chancery Lane. You only have to cross this street. – he answered, pointing at it-
- Thank you very much.

I looked ahead and saw the bloody Chancery Lane underground station. I just had to follow my nose. When I started crossing the street, the old man seized my arm.

- Such a kindness overwhelms me with gratitude, but do you think it's necessary to help me cross the street, sir? –I asked-
- I'll watch for you. As a continental you're not used to the British traffic.

And he left me on the other side of the road, safe and sound from my dangerous expedition.

- Thank you very much, sir. You have saved my life.
- Bus drivers think they own the road. Take care, young lady. And look both sides before you cross dangerous paths.

He waved goodbye and disappeared in the dark. When I was a kid I was told that I had a guardian angel, a mysterious spirit that supposedly floated around me as a lifelong companion to keep me safe wherever I went.

When I grew up I gave up believing and praying and realized that there was no such thing as heaven (a lovely place in the clouds) and hell (a firey pit "down there"). But that night I firmly believed that the old man who helped me cross the street had been my guardian angel.

I could never find The Noble Rot. And no matter how hard I tried, I will never find it. Some years ago I knew that it had been revamped and launched as a French bistro called Kilo Kitchen that didn't survive the recession. As far as Lee Anderson was concerned, I neither saw him nor heard from him again.

Chapter 15: The one night stand

I took the tube back to Russell Square, angry like a snake. Pissed off angry. My heart sank. Was I really interested in a guy that needed to drink up to ten gallons of beer to cheat on his girlfriend and spend the night with me? Did I fly from Spain to Burdishland for that? Certainly not! This was one of the top ten stupid things I had ever done in my life!

Lee fitted well into Sophie's theory. He had miscalculated his chances with women: It was great to get it on Miss Spanish shag trophy while his girlfriend was out, acting big and cocky to score points with his male friends. But it wasn't so funny when he thought I had stood him up and the ladylove was unexpectedly back. So as soon as he heard from me again he ran a thousand miles away. That was exactly what I was trying to digest when I entered the Blickwood Hotel lobby. Patrick McLachlan –the guy at the theatre bookings desk- happened to be there.

- Good evening Miss Martin. –he greeted-
- Good evening Mr. McLachlan–I said, reading his computer-printed name badge-
- I'm sorry about the theatre tickets. Apparently everybody wants to watch "Les Misérables" this week.
- It's ok, never mind.

I walked towards the elevator and he followed me.

- It's a hard rain, isn't it? –he asked-
- Yeah, I'm soaked to the skin!

The guy felt like chatting.

- So, except for the rain and the theatre tickets… are you enjoying your trip to London?-he asked-
- Yes, a lot. –I lied-

I pressed the button to call the lift. Since I was not very talkative that night, he changed the subject to squeeze some words out of me.

- I bet you've never had a Guinness. –he said-
- Yes, I have.
- Where?
- In Spain.
- Nah… that's not real Guinness.
- Why not?
- Because you can only have real Guinness in Ireland. I give you my word of genuine Irish!

I smiled. The elevator doors opened slowly. I entered and he followed me. He pushed the "close doors" button and continued his talk.

- But we could always have a good Lager in London, if you're available and willing. —he said—

Wow, that one was daring! He was asking me out and waiting for an answer on the spot. His offer had caught me unaware, but... what was wrong with it? After all, things couldn't get any worse that night.

- I will be free in fifteen minutes.-he said impatiently-
- I'd like to have a shower and change my clothes...
- Of course, is half an hour ok? —he asked—

I nodded.

- That's cool.
- Thanks. I'll meet you here at the lobby then.
- Ok.

Just as he finished talking, the elevator stopped at the fourth floor, where my room was. The doors slowly opened again and I left. He stood in the elevator, waved goodbye and went back to the ground floor.

In only half an hour I got undressed, had a shower, dressed up casual, blow dried my hair, styled it and made myself up. As far as my inner perfectionist is concerned, nothing will ever be perfect. I took some time to check my appearance in the mirror before I considered I was ready to go out. Only then I went downstairs.

Mr. McLachlan –better known as Paddy- appeared at 9 o'clock on the dot from out of the blue, wearing a tight t-shirt with the sentence "Smell my finger" printed on his chest and showing a little fat beer gut bursting out over the top of his trousers, giving his lower back the appearance of a muffin. That didn't show while he was working behind the reception desk dressed in his blue business suit. But nobody's perfect. Not even me.

Paddy was a genuine black Irish born in Belfast: pale skin, dark hair, blue eyes. A popular theory suggests that Black Irish are descendents of survivors of the Spanish Armada. That was something he highlighted when I told him I was Spanish.

- Who knows, maybe we have common ancestors –he said, giggling- You look very nice... –he said-
- Anna.
- I knew your name. It's very beautiful.
- Thank you... and now that the ice is broken, what's your name?
- Patrick. But everybody calls me Paddy.
- Like Van Morrisson and David Holmes! –I proclaimed enthusiastically-
- Who?
- Two... famous artists from Belfast. –I replied, disappointed-
- Never heard of them.
- Oh, never mind. –I said, feeling like a bloody name dropper-.

I couldn't believe that. Van Morrison was well-known in Spain (that country down South in the back arse of nowhere) where he had a zillion fans. How could Paddy not know him?

- So Paddy… tell me, what kind of music do you like? —I asked him-
- Megadeth, Metallica, Iron Maiden, Scorpions… I like hard rock.
- Ah…

Unfortunately, hard rock never was my thing and my knowledge about that particular field was zero. For the sake of conversation and much to my regret, I had no choice but racking my brains to find good topics of mutual interest and make some effective small-talk. After a few Lagers at a nearby tavern, Paddy started giving me a slurred speech about social rebelliousness and "getting rid of the British Army domination in Northern Ireland".

- When I was a kid there was a checkpoint on our school bus route and almost every day the British soldiers would get on the bus and walk to the back, pointing their rifle at us. People were harassed for no reason, just for being who they are. Children were intimidated. Cars were searched for no reason. My sisters were intimidated by British soldiers who wanted to date them. They were afraid because some women in Derry had been tarred and feathered or even killed by the snipers for that. But on the other hand, they were scared of rejecting them because these guys had guns.

I had no wish to get involved in political arguments about controversial issues, so I managed to switch the conversation round.

- So Paddy… tell me, for how long have you been working at the Blickwood Hotel?
- Three years now.
- And… so far, so good?
- Yeah, but I'd like to find myself a better job.

He was a heavy smoker, probably lighting up a cigarette every ten minutes. A few beers later (Paddy) and two Cokes (me) I had drowned my sorrows and forgotten about my unfortunate and nonexistent date with Lee Anderson, whose sad memory was resting in peace in the back of my mind.

I was still living on the Coke side of life when Paddy implied he would be up for a shag. While he waited for my answer, he lit a cigarette and started blowing thick smoke rings that floated in the air. I invited him to join me to my room.

When we were there, he jumped on my bed and pulled his trousers and boxers down. And then… I could hardly believe my eyes: he had the hugest erection I had ever seen.

- Oh my goodness me… I never… -I wowed, unable to find the right words to finish the sentence, while I stared in shock at his cock-

He looked at me and asked, smiling and shaking it:

- You mean you never had one like this big before?

I felt tempted to deliver a crushing blow to his manly super ego, but I decided to keep my mouth firmly shut.

- Well… not really. –I answered, smiling a worried smile, scared that he would split me in two when the action would start-
- Listen, babe. I won't even touch you if you don't want me to. I just want to lie down beside you and spend the night together.

What an old trick! That kind of sweet talk would soften up any woman, except me; least of all that night. I had heard these words before and was totally immune against them.

- Your eyes are so beautiful … they look like Maltesers[6]. I'll call you Miss Malteser Eyes… -he said, staring in my eyes-

'Shut up, please…' –I thought-

- You're so damn pretty… –he said-

 'Shut the fuck up!!!' –I shouted mentally-

Just as if he could read my mind, he kept quiet and bedded me on the spot. And he took it seriously. To hell with everything.

[6] **Maltesers** are a confectionery product manufactured by Mars, Incorporated. Maltesers consist of a roughly spherical malt honeycomb centre, surrounded by milk chocolate

At least a bit of sex would help me sleep. But it had to be without kissing, like hookers do to avoid intimacy with their clients. I only wanted someone to vent my anger and sadness on; to close my eyes and fuck hard and fast. After all, I was thinking of someone else when I climaxed violently. A few seconds later I came again, and again and still once more. I was exhausted and covered with sweat while he kept thrusting himself into me with force until he groaned and moaned and screamed when his orgasm exploded. I closed my eyes and dreamed of love, lust and laughter; of tears, and rage and fireworks; and of the damn good fucking sex Lee Anderson and I could have had if only we had met that night.

Chapter 16: The morning after

Paddy, the ticket office guy, left my room right after the shag, so – thank God- we didn't have to sleep together that night. That's a fine pleasure I only share with special men and he was not included in that group.

- If my boss found me here in a guest's room, I would be sacked immediately.
- Try not to get caught, then. –I said indifferently-
- I'll do my best. Anyway that wouldn't be serious 'cause I'm leaving to the US on Monday.
- Really? Where to? –I asked-
- Florida. My brother lives there. He has a good standard of living working as a plumber and told me he would find me a decent job there.
- That's fine. What kind of job?
- As a butcher. This is what I did in Belfast until the beef ban ruined the sales and I lost my job.

Some years before, the mad cow disease started spreading across Europe. Entire herds were slaughtered and burned, while a worldwide ban on Burdish beef exports was imposed. In Burdishland nobody wanted to buy beef, not even after the strict quality controls implemented by the authorities and the meat industry.

Meanwhile, factories, farms, restaurants, supermarkets and butcher shops were closed as a consequence of the dramatic drop in sales. In Spain, just like in many other countries, there were notices in all the butcher shops saying "no Burdish beef sold here". But it was useless: people would rather purchase fish or chicken than meat, just in case. As a result, many businesses were closed as well. Everybody was afraid of getting the BSE from eating something apparently as innocent as a healthy fillet steak.

- The hotel job is temporary. I wouldn't like to be selling theatre tickets at the Blickwood for the rest of my life. —said Paddy-
- Of course, not.
- So Monday will be my last day here. I'm sorry but I must be going, I still have a lot to pack…
- Sure, no worries. Good luck in the US.
- Thanks. And good luck to you too. It was… great. I mean the time we've spent together. —he said, blushing.
- Yeah. —I replied-

A bad excuse to leave was better than none. But in all honesty, it was me the one who wanted to get rid of him asap! I had another shower to remove the sweat and the smell of cheap after shave that drenched my body. The morning after I woke up alone in my bed and felt relieved. I had a horrible bed head and a disgusting taste of beer and tobacco in my tongue. Lee Anderson the Great was a prick; Patrick the ticket office guy was a jerk. And I was stupid as hell.

Chapter 17: The Polish cab driver

I had visited the Burdish Museum, the National Gallery, the Westminster Abbey, the Tower of London and the Tate Modern. I really loved the national treasures exhibited in London and enjoyed the visits big time. Nevertheless, I've never been a culture vulture and didn't want to get an art overdose.

After my surreal Friday –definitely, a day to forget- I thought I deserved to enjoy some ordinary pleasures and on Saturday morning I indulged myself doing some retail therapy. I went shopping all my way down from Bond Street to Oxford Circus. I stopped by Marks & Spencer, Selfridges, WHSmith, the Virgin Store and entered all the shops I found on my way. I ended up carrying a number of bags full of fashion clothes, trendy shoes, books, cds, bath salts, perfumes and chocolates. My final stop was Harrods, where I enjoyed big time all the sophistication, luxury and elegance from the display windows, because I couldn't afford spending more money.

My shopping tour was a tremendous success. I pampered myself the whole afternoon and ended up feeling like a queen.

At 6 p.m. I was standing on the corner of Brompton and Hans Road, raising my arm to hail a taxi.

- Good afternoon, madam. Where are you heading? –asked the driver-
- Good afternoon, sir. Could you take me to the Blickwood Hotel at Russell Square, please?

- Sure!

I threw all my bags on the back seat of the taxi.
- We couldn't ask for a better day, could we? —he said-
- I know. There isn't a cloud in the sky. I love this time of year.

The cab driver checked his rear-view mirror and looked at me.
- Excuse me madam, you don't look very British. May I ask where do you come from?
- Sure, I'm Spanish.
- Oh Spain, what a wonderful country! I've been in Benidorm in August 1978! I love the beautiful senoritas, the excellent paella and sangria, the sunny weather all year-round! And the Spanish people are all so warm and friendly!

These were only some of the top romantic myths about Spain, all of them misconceptions. But before you believe everything you hear, let me demystify some of the most obsolete ideas about Spain and the Spaniards:
1. Benidorm is a dump where tourists that look for the cheapest destination get hammered drunk every day.
2. Sangria is a party drink for Spaniards. 95% of the people that drink it in the bars are tourists.
3. The sun in Spain falls mainly on the South and Center. The North is rainy and green like Burdishland.

4. Spanish women spend a lot of time perfecting their image but not all of them look like sexy models. We're careful about how we dress, making sure to always look attractive and stylish. Whether our efforts are successful or not… that's another story.
5. Just because Spaniards greet you with a kiss or would even hug you, does not necessarily mean they like you. Before you get too excited about the kissing, you should know that these affection expressions have absolutely no romantic meaning. We are fairly tactile people that hug, kiss and hold hands all the time.
6. Bulls don't normally run through the streets in Spain.
7. Spaniards neither eat paella nor drink red wine every day. We don't ride burros[7] either.
8. Only small kids and elders sleep the siesta regularly in Spain. The rest of the population would love to, but are normally working.

 The reasons for siesta are basically high temperatures (in summer, in some areas it's simply too hot to be outside) and the midday main meal. Those lucky ones who are able to do so, take a short nap of 15-30 minutes and wait in the comfort of their own homes for the heat to subside.
9. Male chauvinism still exists in Spain, but people from other countries exaggerate it. 50 years ago just a small percentage of Spanish women worked. In the family the man worked and brought the money and the woman stood at home, cooked, cleaned and looked after the children.

[7] Donkeys

And if she worked, she still would do most of the chores at home. Nowadays the scheme is completely different: men and women tend to live similar lives and women are more independent, because they earn their own living.
10. And last, but not least: in the not-so-catholic Kingdom of Spain, most women hate macho men.

Spain is now a pretty progressive country with liberated views about sex.

But I would never let the cab driver know how much Spain had changed since 1978, so I just smiled at him very nicely and thanked him for all the compliments about my country and my compatriots.

- I'm an alien too. —he said-
- Really? You sound very Burdish to me, sir. Where are you from, if I may ask?
- Poland. I'm near retirement now, but I first came to Britain as a child. I've been driving a minicab for 25 years.
- That's a long time!
- Indeed.
- Are you somehow connected to your native country?
- Nah… only my name gives me away. My passport says I'm Pawel Kowalski, but everybody calls me Paul.

I considered I had to reciprocate, as a matter of international politeness.

- I'm Anna Martin. Nice to meet you, Mr. Kowalski.
- My pleasure, Miss Martin.

We shook hands when he stopped at a red light. Mr. Kowalski then gave me a free ride to the Houses of the Parliament and The New Scotland Yard, in Victoria.

- Do you know the Headquarters of the Metropolitan Police?
- WOW! I've seen that sign a zillion times on the TV, but never right in front of me like this!

After some seconds of silence, he asked:
- Would you like to hear some Polish jokes?
- You mean you're Polish and you like Polish jokes? How come? They do not do justice to your compatriots!
- It's better to take things with humour, don't you agree?
- Absolutely!
- Then tell me, what does the message say on the bottom of Polish drink cans?
- I have no idea.
- Open the other end! One more: What's a Polish mine detector? You put the fingers in your ears and tap the ground with your foot!

He talked nonstop and laughed real loud. It was much funnier to see him cracking up with laughter than to listen to the joke itself.

- Have you heard about the Polish cocktail?
- No.
- Perrier and water!
- How do you sink a Polish battleship?
- I don't know…
- Put it in water! Have you heard about the Polish kamikaze pilot?
- No.
- He flew 39 missions!

The guy had an uncontrollable laughing fit. His tears of laughter rolled on the floor.
- You're a talented artist, Mr. Kowalski. –I said- An excellent guide to London and a brilliant humorist.
- That would be very funny indeed.
- And how do you like being a cab driver?
- It wasn't my dream job, but it's all right. I have always provided for my family and made a decent living, you know? The best days are when passengers talk to me and I get home safe and happy at the end of my working day.

A real, humble, everyday life lesson.

Chapter 18: Leaving London

Sunday in London on my own could be murder. I didn't feel like visiting more museums. What I actually needed was a shoulder to lean on, so I thought it was the perfect occasion to phone Jack.

- Hello?
- Jack?
- Speaking.
- Jack, this is Anna Martin. Maybe you don't remember me, but we met in Paris last summer…
- Oh my God! Miss Spain! Of course I do remember you, senorita! If not for you I would still be penniless queuing at a French bank! How is it going with you?
- I'm fine, thanks. I hope you're fine too. I'm spending a few days in London and I wonder if you'd like to meet up, provided that you have no plans tomorrow. I would travel to Bristol if that's ok with you.

I presume he was happy with the idea. In fact, he was so happy that he invited me to stay at his place for a couple of days.

- You need to go to Paddington Station and buy a ticket to Bristol Temple Meads, NOT to Parkway Station. The trip lasts for 2 hours and a half. When you arrive, please give me a ring and I'll pick you up, ok Annie?
- Ok Jack.

- Don't forget: From Paddington Station to Bristol Temple Meads.
- Why Temple Meads instead of Parkway?
- Because I live real close to Temple Meads. So repeat with me:

From Paddington Station to Bristol Temple Meads.

From Paddington Station to Bristol Temple Meads.
From Paddington Station to Bristol Temple Meads.

He surely thought I could get lost somewhere between London and Bristol. Considering that my sense of direction left a lot to be desired, as it had been proved by the Noble Rot incident, I repeated the mantra without a word of complaint.

On Sunday morning I woke up at 8 a.m., packed my trolley, had breakfast at the hotel and walked to the tube station. From Russell Square I took the Picadilly Line, changed trains at Kings Cross St. Pancras to the Hammersmith & City Line and left the train at Paddington.

Once there, I followed Jack's instructions to the letter and bought a ticket to Bristol Temple Meads. The train was almost empty. It was Sunday at 9 a.m. and the good people of Burdishland were either sleeping or having their first cup of tea of the day.

I looked out the window and saw a grey scenario made of buildings, factories and highways in the rain. The train left behind London, Reading, Swindon, Chippenham and Bath. I was still a bit upset with myself about what had happened on Friday night and needed to alchemize my anger into hope.

Under no circumstances should I let that failed night out spoil my trip to Burdishland.

Since the age of 9 I used to write down my thoughts to find comfort and relief when I felt bad. That was my soul therapy. I filled up piles of notebooks with hundreds of pages about everything happening around me. All of them lacked any literary merit. Years passed, moons passed and after my first million words of crap I started producing something in a clear, readable style. I found myself carrying everywhere a pen and a notebook in my pocket because I was constantly being struck with new ideas that I felt compelled to write about and just the thought of forgetting them scared me to the bone. I won a couple of writing competitions and qualified as a finalist in some literary contests. That gave me the determination to go ahead.

I knew that my absolute passion was writing. It was the only thing I'd ever really wanted to do. I wanted to be a writer, but a W-capital writer.

That cold Sunday morning I needed once again a cure for my emotional pain. In that empty train heading to Bristol I took my notebook and started writing:

"My big Burdish adventure began in 1991, when I was 22. At that time, I was working as a junior secretary..."

PART TWO: BRISTOL

Chapter 19: The West Country

Stereotyping is not a good habit, but it's something that we all do. As a Catalan born and raised in the suburbs of Barcelona and living in Madrid –two fiercely rival cities- since I was seventeen, I've suffered the consequences of prejudices and clichés in my own country a number of times. The stupid idea of two confronted cities harks back to the days of General Franco. But unfortunately it spread quickly throughout the country and was widely accepted.

According to the local stereotypes the people of Madrid are generally very kind, friendly, helpful and they love to socialize, while Catalans are stingy, cold, unfriendly, humourless, dull and anti-Spanish. These are only some of the reasons why most of our Spanish compatriots consider us hateful people. Large communities support these cliches while most individuals, if asked one by one, would not admit them. People are easily handled en masse.

In my case, the funny thing is that in Madrid I patiently carry the stigma of being immediately spotted by the locals as "the Catalan girl". The locals look at me askance with suspicion, while in Barcelona my fellow citizens treat me like a stranger –or feel sorry for me- just because I've fully integrated myself into life in Madrid. Therefore, they consider I'm a brainwashed victim that suffers from a bad case of Stockholm syndrome. As a consequence, I'm no longer one of them. Isn't it a most peculiar conclusion? Over the years I've had to learn how to put up with these annoying attitudes.

In the globalized world there should be no place for such narrow-minded views. This feeling of not belonging anywhere reminds me of Arthur Penn's film "Little Big man" (1970), where 121-year-old Jack Crabb (Dustin Hoffman), who resides in a hospice, claims to have been a captive of the Cheyenne, a gunslinger, an associate of Wild Bill Hickok,and a scout for General Custer. His comings and goings from the white man civilisation —where people treated him like a Cheyenne- to the Native American one —where he was treated like a paleface- are the essence of a script that hides a big truth: "Prejudices are what fools use for reason". The original sentence is not mine, but quoted from the French philosopher and writer of the 18th century François-Marie Arouet, known by his nom de plume Voltaire. This stodgy introduction is just to say that I know very well what stereotypes are like because I've suffered prejudice first-hand.

Talking about prejudice and stereotyping, during my big Burdish adventure I was utterly astonished to hear some Londoners say that the people from the West Country were just stupid farmers and that the only good thing there was the M-4 because it was the route to go back to London. Before travelling to Bristol I was equally shocked to learn that some think the people of the West Country are just a bunch of rednecks and farmers with sheep-shagging, in-breeding and slavery historic records. I have been educated in an egalitarian family by politically correct parents and felt very uncomfortable listening to these offensive comments. What was the reason for these wars between "city people" and "country people"?

Why was there so much contempt for the people from the West Country? And last, but not least: what was wrong with being a farmer?

Internet never ceases to amaze me. A short search has given me many valuable clues to the main products of the West Country, apart from cider, wurzels, cheddar cheese, clotted cream and cornish pasties. Surfing from Gloucestershire to Cornwall, and from the Isle of Wight to the Isles of Scilly, I found with just a click an endless list of information about facts, events and celebrities from the West Country whose existence I ignored:

The Glastonbury Festival, the Concorde, Agatha Christie, Sir Francis Drake, Walter Raleigh, Kristin Scott Thomas, Mick Fleetwood, William Golding, JK Rowling, Muse, Bansky, Jenson Button, John Cleese, Massive Attack, Tricky, Portishead, XTC, Bananarama, Elizabeth Frasier, Alison Goldfrapp, the Bristol Harbour Festival, tarmac, the Airbus A380, Jeremy Irons, Blackbeard the Pirate, Schweppes soda water, Matt Lucas and David Walliams, Bristol cars and a of course, the great Cary Grant.

You learn something new every day. Ignorance and apathy are the keys to prejudice and discrimination. So let's stop thinking in terms of stereotypes and maybe the next generation will be better people than we are.

Chapter 20: Bristol

My first memory of Bristol is Jack knocking at my bedroom door at 7 a.m. the day after my arrival. We had been chatting by the fireplace until 2 a.m. the night before and I was exhausted.

- Annie, hurry, look out the window! –he shouted-

I got up as fast as I could, staggered like a zombie towards the window and opened the curtains. The amazing sight woke me up fully: more than 100 air balloons of all shapes and colours were slowly rising over the city roofs. I saw a bear, a Scottish piper, a UFO, a kiwi bird, and an upside down Dutch balloon. I didn't know it yet, but it was the International Balloon Fiesta and from my privileged location in the first floor bedroom, I was attending the 6 a.m. mass launch from Ashton Court. The sky was clear and the sunbeams dropped a pale rosy light on the balloons. Bristol was still asleep. There was nobody outside. I couldn't stop looking at the piece of sky framed within my window, and there I stood until the balloons flew over the roof of Jack's house and I couldn't see them anymore. I put my jacket on and rushed downstairs barefoot.

- Did you know that Cary Grant was born here? –he asked-
- Oh, really?
- Yeah, he lived at the end of the road.
- Wow, I didn't know that such a celebrity lived in Filton Avenue!

- Bristol is not as big as London, but there's a lot of talent and creativity over here. Look at Wallace and Gromit. They're very popular.
- I'm afraid I don't know who they are.
- You mean you don't know Wallace and Gromit? I can't believe that! They're the most famous movie stars of the UK at present. They live at 62, West Wallaby Street. It's just around the corner.

It's so easy to pull my leg! Only when I dressed up and insisted on going out to see where they lived, he confessed that Wallace and Gromit were not the trendiest couple of gay actors in Burdishland but Aardman Animation's most successful clay characters and a world hit in animation cinema.

- Now seriously, Bristol is the city of Bansky and the graffiti boom. The trip hop and the Harbour Festival were born here. I know a certain someone who would be more than happy to show you everything. —he said-
- And who's that someone? Some blind date material you have reserved especially for me?
- Of course not!

You were that certain someone, Ian. Jack always thought that you and I would make a good match and would be finally dating. But it was not your time to step on stage yet.

Chapter 21: Teach your children well[8]

Whether in Burdishland's great public spaces or in small, private areas behind modest homes, the Burdish love their gardens. Just about everyone seems to have one.

Unfortunately Jack didn't, but he had an allotment of which he was very proud. The concept of an urban kitchen garden planted for self supply next to a residential area was completely new to me. That was not surprising: I had been born and raised in the concrete jungle. He took me there on a windy morning and showed me what he grew: green beans, tomatoes, garlic, courgette, onions and leeks. He never missed the hilarious biggest leek and heaviest onion local competition.

- It's a great deal of work to give away most of the veggies, but I'm happy to eat healthy organic food. —he said—

Jack also took me to the local airport, to the zoo, and even to a men's club -the Pill Memorial Club- where I was exceptionally authorised to enter by the gentlemen present and smothered with attentions-.

Jack showed me his favourite towns near Bristol: Kewstoke, Badminton and Clevedon. We crossed the Bristol Channel towards Cardiff and visited the National Wales Museum. We walked up to the end of the historic Grand Pier of Weston-Super-Mare and had a look at the saucy postcards sold there at the news kiosks.

[8] From Crosby, Stills & Nash, from their album "Déjà vu" (1970)

He found them really funny.

In 2008 I read in the internet that the Grand Pier had been unfortunately destroyed by a huge fire. I had a nostalgic feeling of sadness. On our way back to Bristol, we stopped at Sand Bay and sat at a quiet beach cafe where people drank cider while they peacefully read the newspaper and listened to the relaxing sound of the ocean waves splashing and the seagull screams.

But he reserved a special visit for the day after. We went to Bath, one of the most beautiful places where I've ever been. He drove his old Vauxhall and parked at the Royal Crescent, from where we walked towards the center. We had tea and scones with cream and raspberry jam at the Pump Room. I bet you think it's a typical tourist spot with overprized drinks for sightseers with plenty of dollars in their pockets. Yet I like it. I was born into an average suburban family that saved money with much effort to invest it in health and education and never spent a penny on designer clothes or top-of-the-line athletic shoes. The most elegant restaurant where I had ever been was Pizza Hut, so you can imagine my amazement when Jack took me to such a stunning place.

Something funny happened later, while we were queuing at the Museum to watch some objects exhibited in showcases. Among them, there were Roman coins and metal pans that might have been used for making offerings of holy water to the goddess.

The metal pans were deteriorated by corrosion and had small holes with rust around them. Right before us, a father and his 12-year old son patiently queued too.

When they looked at the contents of the first showcase, the kid pointed at the pans and asked his father:

- Dad, what are these?
- Son, —said the father solemnly- you know that the Romans were excellent soldiers, don't you?
- Yes, dad.
- Well, they had firing ranges to practice shooting their firearms, and they used these metal targets.
- WOW! —said the kid, staring at his father in awe-
- Can you see the bullet holes, son?
- Yes, dad.

Jack nudged me. I was unable to stop myself from laughing.

- Do you think it would be evil to enlighten the kid revealing to him that the first firearms appeared in China in the 13th century? —I asked him, in a whisper-
- Yes it would, Miss Smarty Pants. So don't even think about doing that. The kid will discover the truth in the books when he grows up. Let the dad be his hero a bit longer, ok? —he answered-

Chapter 22: A walk to remember (i): The threatening gipsy woman

That morning after breakfast Jack told me he had to go downtown to run some errands. I neither wanted to interfere with his plans nor force him to show me around all the time. I thought it would be good to give him some space and went out for a walk on my own. Before I left, we agreed to meet at noon on the docks and have lunch together at a pub.

I took the No 8 bus from Bristol Temple Meads to the Clifton Suspension Bridge. I didn't know it was well known as a suicide bridge. Reading the plaques that advertise the telephone number of the Samaritans made a deep impression on me. I took a guided tour at the Leigh Woods end of the bridge. When the tour was over I sat on a bench beside the toll crossing box. Pedestrians walked in both directions. An old gipsy woman who came from out of the blue sat beside me and gave me a little branch of rosemary.

- Good day to you, dearie.
- Good day to you too, madam. Thank you for this –I said, shaking the rosemary branch and smiling-.

What a big mistake! Nobody gives something for nothing. She was probably an Irish traveller, a nomadic survivor of the days when gypsies lived on the road, travelling around by horse drawn wagon. I gave her some coins, but she wouldn't go.

She whispered incomprehensible words, took my right hand and started telling my fortune. Her voice was rough and bewitching.

- You are a kind-hearted and good natured child. You come from a good mother and father ...

To start with, as I said many pages before, I was not a believer. And to end with, I was intimidated by her terrifying look. Her big yellowish eyes were like the devil's eyes. Her shiny jet black hair fell all along her back down to her immense waist, which was covered with aprons and skirts.
- You sometimes have a little bad temper, but it soon goes away. You are sad and alone, and some people envy you.

Wasn't she hilarious?
- Somebody gave you the evil eye, but I will take the curse away from you saying nine prayers to the Lord and offering up nine roses on the ninth day of the ninth month.

That was probably the farfetched story she repeated to any poor devil she spotted near her who could be a potential victim. And this time it was me. I pulled my hand away, but she never surrendered, and seized it even stronger.
- You will have a baby girl and live for ninety nine years. And now I will tell you the names of the two men in your life.
- There is a man called Jack who feels for you and another man called Ian who will love you from the bottom of his heart. —she said-

Then she stopped talking, opened her hand and looked at me in the face. Her words became orders.
- You owe me ten pounds, love. —she said-
- You must be fucking crazy.

Her eyes threw daggers at me. My hands trembled with fear and I shivered down my spine. I thought she was going to conjure up some kind of terrible revenge, something like cursing me and my descendants for five generations. She suddenly changed her voice and whispered softly:
- My dear child, you have to pay me so that I can take away from you the curse of the evil eye. Don't be upset. Pay me happy sweetheart, and misfortunes will disappear from your life.

I was terrified by her threatening voice and gave her the ten pounds. As soon as she had the money, she ran away so quickly as if she had to break a speed record. I felt ashamed, humiliated, afraid and furious at the same time. I had been scammed by an old woman, threatened by superstitious beliefs and in spite of it all I paid her! How stupid could I be? As agreed with Jack, I was at the docks at noon sharp to meet him for lunch. But he was not there.

Right in front of me, there was a large truck full of soldiers singing loud. I didn't like the idea of staying there, but had no choice. That was the meeting point agreed with Jack and I shouldn't move until he arrived.

Chapter 23: A walk to remember (ii): The toothless terrorist

Twenty minutes later I was fed up with the soldiers' chants. I stood up, then walked, and finally sat down. They didn't lose sight of me and kept on singing.

The waiting became surreal when a toothless, mad old man, or perhaps just completely drunk, approached me and said in a syncopated most peculiar accent:

- No money. No bothering you. What's the time, please?
- It's twenty past twelve, sir –I answered-.
- No money. No bothering you. What's your name, dear?

That was not fun at all.
- Why? ...
- No bothering you. What's your name, dear?
- Hmm... Martha –I lied, using the same false name I has given to the photo-waiter at the London hotel-

I was scared to death. He gently took my hand, kissed it and left some spittle.
- No bothering you, Martha. At twelve thirty ... BOMB! Irish Republican Army –he said, pointing at the military truck-.

He turned and left quickly. Of course he was mad, but I couldn't help feeling some uneasiness after looking askance at the soldiers.

No way. It could not be true. An IRA activist could not be around eighty years of age, wear a garish beret pulled down tight to the eyebrows, and lean on a walking stick with nails driven into the lower end. Least of all would he openly proclaim his threatens. I started thinking that I was a freak magnet.

Jack arrived at half past twelve. He apologized for being late. I didn't mention the incidents with the gipsy woman and the old weirdo. Otherwise he would have gone mad and even called the police. I entered into his car, and looked through the window while he was speaking.

- Did you enjoy the walk? –he asked-
- Yes, a lot. –I lied -
- I'm sorry for being late, but I couldn't find the keys to my car.
- Oh, it's OK, don't worry about it.

I was too busy looking out the window. Everything outside was new for me and I didn't want to miss a thing.

- I am sorry. I know I'm not the best company for you, dear. I'm an old boring guy, but … -he moaned-
- Don't say that anymore, ok? I like being with you.
- You need a change. You need an exciting change. –he said, afflicted-.
- Yes –I answered, not very enthusiastically-.
- It has to be really exciting.
- Sure.

Jack lost his patience with my resignation.

- What I mean is … what happens to the Spanish men? Are they blind or stupid?

I laughed.

- All you need is to meet an interesting guy. You need a true love.

"Doesn't everybody?" – I thought-

Chapter 24: Guests and fish

Jack's invitation to stay with him for a couple of days finally became a whole week. One day we had lunch at a chippy near Christmas Steps. Jack ordered fish and chips for the two of us.

- Only local stuff! —I repeated my war cry enthusiastically-

That day to my surprise, the "local stuff" came wrapped in newspaper. The fish was hollow inside with a sort of fossilized skin, and the chips tasted as if they had been fried in motor oil.

- Sorry Jack, but I won't eat this. —I said-
- Why not? Don't you like it? —he asked-
- Newspaper ink is toxic and I want to live a long life. -I said-

That was just an excuse. The food was simply inedible.

- I didn't know you were so picky!
- I'm not picky!
- When I was a lad fish & chips were always wrapped in newspaper and nobody died for that! Ah, greaseproof paper... what a sad loss in the march of progress! —said Jack-

Jack ordered a hamburger for me and kept my fish & chips for him.

- I'm so hungry that I could eat a horse! -he said-

He started a casual conversation with the owner of the restaurant and proudly –I'd rather say foolishly- mentioned my nationality. The old cow stared at me like a hawk, while a string of rudities seemingly without end spewed from her mouth.

- Spaniards are greedy dicks that killed thousands of people, stole the gold of South America, destroyed other cultures in the name of God and still take great pleasure in supporting violence and brutality towards animals! –she spat at me-

Why would people judge others for what their compatriots did five hundred years ago? I paid no notice to what she was saying and asked her if the Food Inspectors knew that she used toxic printed newspaper to wrap her rubbish pig swill food.

- We only serve top quality food here, madam. Whether you're able or not to appreciate and enjoy it, that's not my problem –she replied-
- Well, you can take your top quality food and shove it up your ass! –was my reply, as I rushed out of the place, leaving behind the lady and Jack -

I sat on a bench in the street and waited for him. Five minutes later, he left the chippy carrying a plastic bag that contained the two portions of fish & chips and the hamburger.

- What am I gonna do now? I used to come here for lunch so often that the waiters remembered what my order was! –he complained-

- This place sucks, the staff is rude and the food is disgusting! –I said, enraged-.

He looked at me, very serious.

- Talking about fish... you know that guests, like fish, begin to stink after three days? –he asked-
- If my memory serves me well, you invited me to stay with you for a week but if you consider that I already stink, just let me know and I'll go back to London. –I answered-
- You do. Stink.
- Ok, I got the message.
- You look cute when you're angry.
- That's just what I needed to hear!
- C'mon, silly. You still don't get it, do you?
- What is it I have to get?
- My joke!

Definitely, I was still too sensitive to appreciate these pearls of Burdish humour.

Chapter 25: The arrangement

- Again, what was the name of the guy that stood you up in London? —asked Jack—
- Lee Anderson. —I said—
- Oh yes. And how does he look like? Is he handsome?
- Very handsome, distinguished, well dressed, and clever.
- Then, I don't like him.
- Why?
- Because he'll make you suffer. Forget about him. I'm going to introduce you to somebody interesting. —he said—
- Who is it?
- Just wait and see —he answered, smiling—

He drove to Rockleaze and pointed at a nice Victorian house built in front of a large meadow where a group of kids were playing boomerang games.
- The Logans live there. I already spoke to you about them.
- Yes. Are they that family you're friends with?
- That's right. I've known John for more than thirty years now. And I know his children since they were born. It's a shame that Ian is not home now. I can't see his car.
- Who's Ian? —I asked, a bit alarmed—

The reason for my surprise was that I suddenly I remembered that the gipsy woman at the docks had mentioned two men named Jack and Ian that were supposed to play an important role in my life. Although those were common names in Burdishland and the prediction was just a product of her imagination, I was shocked by that amazing coincidence.

- Ian is a friend of mine's son. –said Jack-
- Whose friend? –I asked-
- John Logan.
- How did you know him?
- At the Bristol South swimming pool. I worked there as a swimming instructor.
- Was he a swimming instructor too?
- No, he was a ship's captain.
- Did he serve in the British Navy?
- No, he was a merchant seaman. But tell me Annie, for what reason are you more interested in the dad than in the son?
- I was just curious. Ok, tell me about the kid then.
- He's not a kid, he's a man.
- Ok. Tell me about the man, then. –I said, rolling my eyes-
- He's 28, very nice and clever.
- Great.
- And he's available. –he said-
- That's cool but where's the catch?
- Come on! I just want you to meet him. You won't die for that.

- I appreciate your efforts, but this sort of arrangements never works.
- What sort of arrangements are you talking about?
- Blind dates.
- It won't be a blind date.
- It will, as blind as a bat, indeed! I've never seen him! He could be horrendously ugly, weird or gay! I have nothing against gay people, but I'm straight!

Jack started laughing his head off.
- I'm serious! My worst blind date ever was a door-to-door Bible seller whose breath smelled like farts, wore white socks, had mustard stains in his tie and bit his nails all the time. And he tried to sell me a Bible!

Jack split his sides with laughter. When he calmed down he said:
- Oh my... I haven't had so much fun since I was a kid. For your peace of mind, Ian isn't horrendously ugly, weird or gay. He's good looking, very nice and won't pester you trying to sell you a Bible. But no worries. Maybe I've pushed too hard.
- No, it's ok. I'll meet him. But I'd like to know something else about him.
- Fair enough. What is it you want to know?
- Everything! I leave it to you.

- He went to Grammar School and then to the University of Southampton, where he graduated in Russian and French. He's just back from a one-year stay in Paris and Leningrad[9].

At least you had a good education. I must admit that this time Jack got me a bit interested, so I decided to pay attention to what he was saying.
- He plays guitar at a rock and roll band. He also has a very old and nice car. –he said-

That valuable piece of information made me think that maybe you would be well worth the effort.

[9] At present Saint Petersburg.

Chapter 26: The plot

Your father paid us a short visit on Tuesday afternoon. I had done my hair some minutes before and the fresh herbal smell of my shampoo and eau de cologne had spread throughout the entire room. When your Dad arrived I rushed upstairs to let Jack and him talk privately, but from my room I could hear their conversation.

- How come the house smells so nice instead of stinking like 4-day old sardines, as it usually does? —asked your father-
- Because I ran out of cat food this week! —answered Jack-

They both laughed.

- You're right, my house never smelled so good. You must blame my visitor for that.

He called me and I went downstairs to the living room. Your father looked very pleased when we were introduced. I realised that he was surely well into the matching plot too. After the introductions, we had a short conversation that dealt with the usual topics and left some minutes later. He made a very good impression on me because of his nice manners and extreme kindness.

He came back to Jack's house on Thursday morning, with the purpose of inviting us to dinner on Saturday. He wanted to introduce me to the family.

- But we don't eat paella at home, Annie —he said-.
- Don't worry Mr. Logan. In England I only have local stuff.

When he waved goodbye to Jack, I heard him say:
"What a nice kid".

I was a bit concerned about that dinner. I was not sure about what to wear, how to behave or what to bring.
- You will be very pretty no matter what you put on. Just be yourself. They will like you –said Jack-.

But I wanted to be very polite and leave a good impression, so on Friday I bought two bottles of the best Spanish wine I could find and a flower bouquet for your mother. Jack told me that you were nice and hospitable people. He told me about your 3 older sisters, about your parents and the number of differences that you couldn't settle. But in Jack's words, none of them could compare to you Ian, so clever and charming, outstanding in a crowd, surrounded by a delicate halo of kindness, good manners and intelligence. The more he told me about you, the more I felt like meeting you.

And this was how I knew that you were neither a door-to-door Bible seller whose breath smelled like farts, wore white socks, had mustard stains in his tie and bit his nails all the time, nor a horrendously ugly or a weirdo, but a very likeable man.

Chapter 27: Dinnertime

Jack told me to take all the time I needed to dress up. I took a hot bath and washed my hair. I only had a blue dress apart from two pairs of ripped jeans and hoodies, so the choice was easy: the dress would be more suitable for a family dinner.

- How do you like it Jack? –I asked-
- You look radiant. –he answered-

We left at 6.30 p.m. and arrived at 6.53 p.m. We waited 6 minutes and at 6.59 p.m. we got out of the car. Jack was never late but he didn't want to be earlier than expected either. He was always punctual as a Swiss watch.

Your parents opened the door. The radio was on: ragtime and classic jazz to create a friendly atmosphere and help breaking the ice. I was introduced by Jack, carefully observed by your mother and sisters that gave me a smile wide as a mousetrap, licked by the dog, ignored by you.

Your mom had laid a very nice table: white tablecloth, shiny cutlery and classic china dishes. She had an excellent taste in decoration. She decided that you had to sit beside me and kindly take care of me in the best way possible, always under her strict surveillance. Your sisters nudged and smiled. It was so obvious and embarrassing!

You were cold blooded and very shy. You didn't dare talk to me and just passed me the vegetables. I felt like pinching your leg under the table while you did.

- Help yourself —was all you said—.
- Thank you —was all I answered—.

The menu consisted of a delicious roasted chicken, dressed with cream sauce and cheered up with carrots, potatoes and peas. My imagination ran wild and I felt the irresistible impulse of being naughty. The challenge was simply exciting. I deliberately left my knife fall on the floor.

- Oh, sorry, I'm so clumsy —I said-

I hoped you would follow the game so that we would meet somewhere under the table. We could have picked up the knife at the same time and laugh, while everybody would be having dinner and wouldn't notice. We could have even left them there in the house and rushed out for some fun. But you went to the kitchen and with extraordinary sangfroid got me another knife instead. Some say that the budding gentlemen may lose their Burdish composure only after drinking large amounts of alcohol and watching a few football matches. But a family dinner was not the right background to get blotto.

I noticed my presence made you feel very uncomfortable and made sure I took all my chances to overcome your ridiculous resistance: I really enjoyed pestering you for a while. But your weak replies exhausted me, so I ended up ignoring you.

Your mom decided to hold control of the situation and I was subject to an interrogation as one would expect of the Spanish Inquisition.

She wanted to know everything about me: career, job, hobbies... anything to bring out my presumptive skills and personal qualities. Perhaps this way you would notice me and get interested. She made me talk non-stop to find out what the two of us had in common, but when she realised that you were immune to my charms, she gave up too. That family dinner was a meat market: I had been invited for nothing but the hook up!

I had the unpleasant feeling that my sole presence was bothering you. You didn't want to be rude but didn't want to play your mother's game either, so you decided to be indifferently well-mannered. As soon as you realized that I had stopped teasing you, you felt relieved and definitely free from any obligation. Free to have your tea on the other side of the room, miles away from me. The feeling was mutual. I overheard you and Jack mentioning my name and pricked up my ears.

- Hey, what do you think? –asked Jack-
- Out of two marks, I'd give her one.-you answered-

After hearing that, I thought you really were a condescending prick. Men sat on the other side of the room to talk about the top burning issues of the moment:

The recession into which the country was falling; the alarming news from Kuwait about the passengers and crew of the Burdish Airways 149 flight from London to Kuala Lumpur, who had been captured by Iraqi forces during a stop-over at the international airport of Kuwait city and became part of the 'Human Shield'; the privatisation of the major Burdish utilities and the NHS.

101

It was crystal-clear that you were not in the least interested in me, so I began to feel like a prisoner in your parents' living room. Out of politeness and respect I continued drinking my tea, while your mom and sisters talked to me. It was just small talk at the beginning, but it soon started to sound again like a third degree rather than a conversation. A voice inside my head shouted "Please get me out of here!" but Jack wouldn't listen until it was 11 p.m. and he considered it was time to leave.

Chapter 28: The aftermath

Neither Jack nor I said anything in the car. When we arrived to his house, he lit a fire in the dining room, took his bottle of brandy, prepared me a hot tea and switched the radio on. I was saddened.

- Don't be disappointed. –he said-
- I am not disappointed. I told you these arrangements never work, Jack. I didn't expect anything more.
- He was feeling pressured. I know he would have been very gentle with you if his family was not there.
- Come on, I heard him say that out of two marks he'd give me one.
- Oh my, you heard him!
- Yes, I did. It's quite chauvinistic to give me a rating. Who does he think he is? God's gift to women?
- Oh come on, it's not the end of the world.
- That's right, but I didn't like it. Now if you'll excuse me, I'm going to bed. I'm very tired.

Jack left his glass on the table and hugged me. His fingers touched the sides of my breasts, but it seemed incidental and brief.

- I've been hard since you arrived, Annie. Do you understand what I mean? –he said, pressing his chest against my breasts-.

Of course I understood what he meant, but I was in shock. I couldn't believe what I was hearing. Jack was like the granddad I never knew.

And who would have thought he didn't see me as the grandchild he never had, but quite differently!

He kissed my lips but I kept them firmly closed. Shivers ran through my body as his hands stroke my hips. He kept on kissing and hugging me for endless seconds, regardless of my resistance until he realised I was rejecting him.

- I'm sorry. I should have never done that. –he apologised-

I looked down very embarrassed, not knowing what to say or do.
- I'm sorry, it won't happen again –he insisted, blushing at his own audacity-.

Right. It would never happen again. I went upstairs to my bedroom. That night I bolted the door to avoid untimely apologies that would make things even worse. I quickly packed and took French leave.

Jack and I lost track for almost two years.

Chapter 29: Cinderella at midnight

I disappeared from Bristol in the 4.47 a.m. train to join nurses, bakers, factory workers, baristas, stock clerks and other early morning commuters. The train was packed to explosive capacity because —as I heard from a lady next to me- it was running with fewer carriages than normal, but I could find a window seat. There was a small unfolding table beside it. I looked for my notebook and continued writing about my adventures and misfortunes. It was soothing. Sometimes I couldn't hold back my tears and had a good quiet cry.

At 6.30 a.m. I arrived to Paddington Station. I took a taxi to the hotel, packed the rest of my luggage and rushed to Gatwick airport. I felt like Cinderella at midnight: the party was over, my Prince Charming had vanished, the magic was gone and in a few hours I would be weeping ash out of fireplaces, down on my knees scrubbing floors, cleaning and fetching, fetching and cleaning. In other words: I would be back to EastPack Madrid typing letters, answering the telephone and telling everyone about my failed date with Lee Anderson. I realized the dream had ended and got my reality check.

At the airport things didn't look any better. My flight was delayed 4 hours. As compensation for the trouble caused, the airline gave me a 3-pounds coupon to use at Burger King. I had a hunch that it would be a long night, so I gobbled up my cheap dinner and then walked back to the waiting room. I sat next to an old lady that asked me if I was Spanish. She looked very happy when I nodded and chatted non-stop reminiscing about the good old days.

The disabled people helper who was taking care of her asked me:

- Excuse me, do you speak English?
- Yes, I do. –I answered-
- Are you flying with Air Europa to Madrid at 19.30h?
- Yes.
- Would you mind to translate my words for this lady? Her English is poor and I need to ask her a couple of questions.

"What about your Spanish, dude? Is everybody out of the Commonwealth supposed to speak good English?" –I thought, tired and irritated because of sleep deprivation-. I was not in the mood to speak any language least of all to translate, but I smiled and nodded as expected. After all, I couldn't blame him for my anger.

The old lady's name was Carmen. I told her I was going to be her interpreter with the airport employee that would be taking care of her and she looked quite happy.

- Could you please, tell her that I will pick her up exactly one hour before the flight takes off with a special vehicle, so that she doesn't have to walk to the plane?

I did, but the old lady didn't seem to care at all. I was quite surprised that her family would allow her to travel alone.

- Sir… have you noticed that this old lady is… a bit of a dotard? –I asked him-
- Yes. –he answered-

- She needs surveillance until her family or whoever fetches her in Madrid.
- I know.

He didn't seem to be worried about it.

- Would you mind looking after her until I'm back? I'm going to bring the buggy. Would you like to join us from the terminal to the aircraft? —he asked me-
- Can I?
- Of course! If someone asks you, just show them your air ticket and tell them you're her companion!
- But it's not true! Won't it be a problem if I say that? —I asked-
- Not at all! I will confirm it.

So from that very moment on, I had been officially appointed as Carmen's assistant. After our short conversation, the guy left and I stood with the granny that had become very fond of me. He came back half an hour later driving an electric golf cart that he parked carefully at the entrance of the check-in hall. Then, he sat beside me opposite to Carmen and started talking to my left ear.

- My name's Harry. —he said-
- Nice to meet you Harry, my name is Anna.
- I live in Crawley, near the airport. Two years ago I lived under a flight path and I could almost touch the planes. My house was covered in this film of dirt, it was quite awful. I ended up moving.

At the same time, Carmen was telling me about her first flight in 1943 to visit her sister, who lived in London, talking into my right ear. Just come seconds later I couldn't understand a word they were saying. But as usual, out of politeness, I alternatively smiled and nodded to both of them until I had a stiff neck. When they made a pause to breathe, I relaxed, looked ahead and hoped that my flight would be soon advertised at the departure boards.

At 10.30p.m. Harry asked us to get into the buggy. To my astonishment, Carmen hopped in quite easily, while I had some trouble with the bags I carried, containing two decorated teapots and other pottery articles especially wrapped to travel overseas. We took a huge elevator (or a lift, whatever you prefer) that went downstairs. We showed our passports and air tickets at the security checkpoint. A policewoman asked me what I was carrying in the bags and, of course, she unwrapped all my packages. That was quick. We boarded the aircraft exactly at the same time as the rest of the passengers.

More surprises were awaiting me before leaving Burdishland: there was a riot in the plane. A drunk passenger tried to choke the woman sitting next to him and screamed the plane was going to crash. He was arrested before the plane took off, escorted to the airport and kept there in police custody. There were many youngsters among the passengers. Most of them were Spanish students travelling back home after a short summer stay in England to improve the language. The aircraft was buzzing with excitement and crammed with teenagers talking loudly.

There were drugs and alcohol and one girl desperately asked for MDMA[10]. They drank and sang as loud as they could until they dropped. It was their last teenage rebellion before they would arrive home and fall within mom and dad's jurisdiction again.

I was too old for that kind of scene.

The nightmarish flight landed in Madrid at 2.30 a.m.

[10] **MDMA (3,4-methylenedioxy-*N*-methylamphetamine)** is an empathogenic drug of the phenethylamine and amphetamine classes of drugs. MDMA has become widely known as **"ecstasy"**

PART TWO: BRISTOL REVISITED

WICKED GAME[11]

The world was on fire and no one could save me but you.
It's strange what desire will make foolish people do.
I never dreamed that I'd meet somebody like you.
And I never dreamed that I'd lose somebody like you.
No, I don't want to fall in love
With you. (...)

Chris Isaak

[11] From his album "Wicked Game (1989)"

Chapter 30: Two years after

Except for the annual Christmas greeting cards, Jack and I were not in touch anymore. I suffered from a lazy blue period and disappeared from the scenario for almost two years. Nevertheless, he was often in my thoughts and I regretted having lost track. Two years of silence were punishment enough.

At the beginning of October he wrote me a short letter, just to say that he was coming over to Spain. He was joining a group of people interested in visiting some vineyards and wine cellars in a small town in Central Spain —not worth mentioning, let's call it Tijuana- and he thought he had to let me know. It was hard for me to understand what made him travel to that remote provincial Spanish town lacking any interest except for the wine, which had never been in the least a matter of interest to him. That sudden journey took me by surprise, but I phoned him and quickly made arrangements to meet him on the weekend.

He mentioned you for the first time in his letter.
He said that you were alone and helpless.
He said that since women had disappeared from your life, you hung out every weekend with the friendships and drank like a fish until the break of dawn.
He added that you had been squatting at mom and dad's house until the age of 29.

You lived there fat and happy until you realised that you were not allowed to question their authority, because they expected you just to shut up and obey. And that was not fun at all.

Jack guaranteed that you and I could have a good time together if only I decided to fly to England. He added that your parents would be more than happy if we started going out. That scared the hell out of me. Why was I on everyone's lips? And for what reason did we need parental blessing to date?

Hanging out was fine but I wanted much more from you: I wished I could send your emotions into a haze of unbearable desire, discover your most beautiful self and bring out your dormant lust and passion.

Chapter 31: Welcome to Tijuana[12]

As soon as I arrived in Tijuana, Jack changed his mind and decided to skip the vineyard tour. Instead of that, we spent the time walking and updating each other. During my last day there, we sat on the terrace of a wine bar where old ladies and their old husbands had the traditional Spanish weekend appetizer. All of them were dressed up in their Sunday best. In fact, they all looked like grotesque mannequins at a big fat gipsy wedding greeting each other with kisses, overdoing affection, tickling their thick gold bracelets, frightening little kids. The elders filled the scene all over except for that small island where Jack and I were having a coffee. It was a nice little place in the sun and the fresh air, where his voice and my laughter could be heard while the florists sold out their last chrysanthemums. It was Sunday and All Saints Day.

Jack spoke about you like a proud father would about his most dearly loved son. You hadn't experienced many changes in two years. He said you were living on your own in a nice bachelor's flat, happy inside your bubble, comfortable in your decadent routine, but still hopeless, cold, indifferent and yet so sensitive and damaged, unable to forgive yourself, deliberately heartbroken. Not like me, foolishly hopeful and in permanent lovesickness.

[12] From Amparanoia "Welcome to Tijuana"; and Manu Chao from his album "Clandestino" (1998)

The two of us enjoyed complaining but the difference between you and me was that you were life's spoiled child and chances would continue to knock at your door forever. You would go on missing your chances, while I'd take anything this life could offer me, including the crumbs of comfort. Jack went on talking about you. He had carefully read your dissertation on French and Russian cinema.

- A little masterpiece -he said-.

But your father didn't. You had worked so hard in these pages about Truffaut, Goddard, Eisenstein and Vertov ... but dad couldn't understand anything at all. He thought it was just sophisticated name-dropping and was not really keen on the details. The boy that suffered from serious lack of warmth had left him cold many years ago.

Jack asked me to choose a nice postcard to send you. I pointed at an old black and white watercolour of the city -something nicer than a horrible colourful snapshot of such an awful place-. I thought it would be more suitable for someone like you. Jack took his pen, wrote some lines and passed me the postcard.

- Write something to him and then post it when you go back home. There's no hurry. —he said-

You and I never did too much talking, Ian, remember? The more I thought, the less I could imagine what to write you on the postcard. I finished my drink, put the postcard in my bag and thought I'd better wait for inspiration to come find me later.

But Jack didn't give up.

- Ian asked me to give you his best regards. –he said-
- I'm overwhelmed by his kindness! –I replied, sarcastically-
- Honest, he did!
- Thanks then, that's nice of him.
- And he said that if you ever came over he would be very pleased to take you out. So you'd better do now that he's available or it will be too late, Annie – he said laughing-
- Did you or his father ask him to say that?
- No.
- Something tells me that it's not completely true.
- I just said to him that you would be coming over sometime and asked him if he'd like to take you out. And he said "Yes".
- That's not exactly what you said before, Jack.
- Listen, my dear: we all have our will. And if he said he would be very pleased to go out with you, I'm sure he really meant it.

It was strange to hear something kind from you. In fact, it was actually strange to hear anything at all from you. I must admit I felt flattered and awkward at the same time. Life was offering you another present: a second chance with me that you could either take or miss.

You had the best matchmaker in Burdishland. He knew that I dreamed of a man literally clever, nice, witty, tall, handsome, financially independent, Northern and above all, single -what you might call a unicorn-. But Jack granted that you met the demanding profile.

Everything was always so easy for you, well organized by middle persons who worked really hard to match us and looked so badly disappointed when you never made a move. As if they didn't know you.

Jack could not remember your zip code, so my postcard reached you one month later, when his trip had long been forgotten.

- Bristol 1 will suffice -he said- Bristol postmen are extremely clever.

I remember writing something completely stupid, like "prepare the kettle and the scones; I may be coming over soon". I was only trying to sound nice, but I was very excited about seeing you again and jumped into that situation without any brakes. Still today I wish that postcard had never been delivered. I have a fine sense of the ridiculous.

Finally Jack overcame my resistance: I took the bait and started seriously considering the possibility of spending some days in Bristol after Christmas.

Chapter 32: The mysterious host

1992 was the year of the Barcelona Olympic Games, officially known as the XXV Olympiad. Montserrat Caballé was asked to sing "Barcelona" at the opening, however she declined as Freddie Mercury, deceased in 1991, could not be there.

The infrastructures built for the games changed the city for the better, created 20.000 permanent jobs and left an important legacy of internationalization and competitiveness. 1992 was also the year I went back to Burdishland, exactly on January 2nd.

I landed at Heathrow. It was raining hard. Jack was waiting for me when I left the baggage reclaim area. We hugged. He was a bit shy. It took him some time to relax and feel confident. He had bought two tickets to travel on the National Express Coach from Heathrow to Bristol.

- I hope you don't mind if we have dinner at a friend of mine's place. —he said as soon as we met-

I only expected it wouldn't be a guy called Edgar, who lived alone with six pitbulls in a ramshackle house near the airport. Once we paid him a visit and he didn't open the door. He stood in the garden behind the fence while the dogs barked like hell and Jack handed him a bag with some veggies from his allotment. Edgar was very old and he looked dirty and untidy, like the weeds that grew all over his garden.

- Who's going to be our host? Somebody I know? —I asked-

He stared at me and chuckled.
- Oh please tell me who is it. Perhaps... Edgar? —I asked again, hoping it wasn't him-
- No, it's not Edgar.

That was good news.
- Maybe Lou, the Greek guy and his wife? —I asked again-
- No, it isn't Lou either. —he answered-
- Oh please, please, tell me who is it...
- I won't tell you. —he said, mercilessly-
- OK, I won't ask then.

I was very tired and didn't feel like having a formal dinner at a stranger's place but I accepted the invitation. What else could I do? I'd have enough time to relax and sleep in the following days.

The coach arrived at the Bristol station around 7.00 p.m. It was dark and wet. Jack and I left in his car to the mysterious dinner. I had no idea where we were going to. The streets looked deserted and shiny because of the rain. When he saw a plaque that read "Montague Street, CITY OF BRISTOL" he parked and said:
- End of the trip.

Jeez... a formal dinner... what a drag!
- It's here, Annie —said Jack-

We entered a residential flat building without elevator (or lift, as you like it) and went upstairs to the second floor. I was at the bottom of the last flight of stairs when I heard a familiar voice ask me:
- How is it going after two years?

I looked up and I had to hold on to the banister to keep myself from falling down the stairs. There you were, smiling at me from the door to your flat! I couldn't believe my eyes. What a warm welcome! I forgot about the world and smiled back. The memory of that precious moment is still fresh in my mind.
- Still great, just two years older! –I answered, giggling-
- No one could tell, you look exactly the same –you said-
- The same goes for you -I added-

There you were, without mom and dad, feeling free and being nice to me. Millions of butterflies started fluttering around inside me.

Chapter 33: After-dinner convos

It was fun to think that something exciting could happen between us as a result of Jack's plot. I knew he had carefully planned his strategy and worked hard on it.

I haven't forgotten the menu: wild rice with cranberries and roasted pork with chestnuts and Chinese mushrooms; vanilla ice cream and cookies for dessert. Did you do it to make up for your appalling lack of manners during the regrettable dinner at your parents' house two years before? I'd like to think so.

- Thank you very much for the dinner, Ian. It was delicious. You're an excellent cook! –I said-
- He bought everything at a Chinese restaurant –said Jack laughing-
- Shut your face you cheeky git! –you whispered to Jack laughing too, as you tapped his arm-

Your accent gave a lovely lilt to what you said. After the dinner we had a cup of tea and chatted.

- Ian has a large collection of albums and an excellent stereo – said Jack, acting as master of ceremonies-
- I see –I said, pointing at the shelves where he stored his music- What is your favourite music, Ian? –I asked you-
- That's hard to answer. I like a little bit of everything.
- Can I have a look? –I asked-
- Of course.

I was impressed by the variety of styles represented in your collection. The Fuzztones, The Yardbirds, Chuck Berry, Bo Didley, The Kinks, The Sonics, some Britpop, punk, new wave and a great many others. You took an album from the bookcase and gave it to me.

- Do you like Steve Hackett? –you asked me-
- I know him from Genesis but I have never heard the music he plays in his solo career –I answered-
- Would you like to listen to it?
- Yes, of course!

The album's name was "The unauthorised biography". I have an eclectic taste in music too but not as rooted to the classics as yours. I grew up listening to The Jam and The Clash. When I was a teenager, I discovered King Crimson, Yes and Brian Eno. Then I had an intense prog phase. But the bombast symphonic stuff was swept away soon in my collection by the post punk era and the myriad of alternative rock bands that became widely popular in the 90s. I really enjoyed discovering Steve Hackett's solo work. The album cover was amazingly surrealistic with medieval and romantic reminiscences. And the music was beautiful, poetic and mesmerizing. While commenting on it, you confessed to being a diehard vynil fan.

- I think vinyl sounds better than CD. –you said-
- So you're a real vynilphile! Some myths just never die, hahaha. –I replied-
- Really, it's technically proved!

- But a vinyl is more vulnerable to scratches than a cd. Evolve or die…
- You're right. Anyway, some elements are lost with the CD: the folder, the inner sleeve, the label indicating side "A" or "B".

At that moment, Jack thought that his presence was not required and interrupted our conversation abruptly.
- Kids, I must be going. It's late and I need to get up early tomorrow.

"What a bumer!!! We haven't even started and we're already leaving!!!" –I thought, quite disappointed- But Jack, the man who had a solution to everything, kept an ace up his sleeve:
- If you're tired you can come with me. But you may like to stay and have a drink with Ian…
- What would you like to do? –you asked me-

I definitely preferred to stay at your place rather than sleeping at Filton Avenue, but it was so embarrassing to say it openly that I wished I wore a bag on my head. Your question was too direct. I hadn't been officially invited to stay. And if I was, it would be pretty obvious what my expectations of you were. So I tried to save face by racking my brains looking for an acceptable answer.
- I'm a night owl. If you feel like and are willing, I'd be very pleased to have a drink with you. –I said-
- Be my guest. I have a bottle of excellent Scotch.

- It will be a pleasure to share it with you.

I felt much better. A drink was an excellent prologue to seduction games.
- You can call me when you want to come back and I'll fetch you – said Jack-. Doesn't matter what time is it.

"Oh shit ooh shit! Here he comes again!" –I thought-
- No, it's ok, I'll take a taxi. –I said-
- I'll drive her back, Jack. No worries. –you said-
- Great then. Annie, I'll leave the keys to the house under the doormat –said Jack-

The situation was getting worse by the minute. I wouldn't take a taxi and you wouldn't drive me to Jack's house. I just wished the two of you would immediately stop talking nonsense because I was bound and determined to stay at your place and sleep with you, even if it was the last thing I did. I was never so resolute, never so strong, never so full of volcanic energy, as at that very moment.

Chapter 34: Just you and me

As soon as Jack left, you poured two glasses of that excellent Macallan, switched the lights off and turned the lava lamp on. The coloured wax rose and fell in mesmerizing globular shapes. As I said some Chapters before, I don't normally drink but that night I decided to make an exception.

You proudly showed me the albums released by your garage-rock band: Tea & Norbert Lemons, a funny name. I complimented you and noticed that your pale cheeks were turning bright red. That was cute. I have a soft spot for shy guys. You sat on the sofa. I sat on the couch. We were too far from each other, politely sipping whiskey, looking at the Christmas cards on the shelves and the posters on the walls and looking for subjects to talk about. Your stereo played one of my favourite bands: The Smiths.

> "I am the son and the heir[13]
> Of a shyness that is criminally vulgar
> I am the son and heir
> Of nothing in particular.
> You shut your mouth.
> How can you say
> I go about things the wrong way?

[13] "How son is now" (The Smiths, from their album "Meat is Murder")

> I am human and I need to be loved
> Just like everybody else does ..."

We spoke about cinema, music and books until it was 1.30 A.M. There was intellectual magnetism between us, but no slow dancing, no jokes, no innuendoes, no nothing. I wondered when would you decide to display your abilities in the art of seduction and soon I realised that you were deliberately avoiding that moment.

You started an artsy-fartsy questionnaire just to check if we were on the same wavelength. I passed the test with flying colours but some minutes later I was already fed up with questions about Tarantino's films scripts, David Lynch's TV shows and Kriztoff Kieslovsky's trilogies. I was not keen on showing my cultural skills at that moment, least of all on intellectual championships that threatened to last until the break of dawn. I reached the conclusion that it was time to take action and let you know that you had a chance. I feared being blatantly flirty so I kept the conversation serious and started sending you mixed signals. I smiled just to make you feel special. Just to make you understand that I had a huge crush on you. You smiled back. I looked into your blue eyes, cold as ice of a thousand years in the making, trying to approach you. But you averted your gaze and stared off into space.

I kneeled down on the carpet right beside you and played with my hair as I softly spoke to you. That did work.

- You look nice with that hairstyle. -you said-
- You mean my side braid? –I asked, shaking it-

- Yeah. It gives you a very bohemian feel.
- Thanks. —I whispered, giving you a smile-

Good. You were making progress. Soon you would be eating out of my hand. I had to take advantage and make some moves. After two shots of Scotch I was tipsy and didn't hesitate to get real close to you. Otherwise, we would have been talking about the Bristol cultural offer for eons.

After the approach my lips brushed yours. It was a spontaneous and impulsive kiss. You lightly stroke the nape of my neck with your fingers and sucked my lower lip. But suddenly you stopped. Were you just spinning your wheels?

- What's the matter? – I asked in a whisper-
- This is very embarrassing —you said-
- Did I bother you or something? I'm sorry if I did…
- Oh no, not at all.
- What is it then? Am I too daring?
- Nooo, you're fine. I'm just trying to overcome my fear of rejection.

Among my scarce virtues, there is an empathic mind. I sometimes find myself analyzing everything and this helps me understand situations and find solutions to my everyday problems. That night I realised you were in a state of mind that made you incapable of doing or saying anything for fear of being rejected by me.

Paradoxically, your anxiety would be leading you to reject me if you panicked while trying to avoid my rejection. That was a big catch-22.

- Ian, it's pretty obvious that I'm not rejecting you so there is no point in thinking that I… –I said, trying to rationalize-
- Don't take it personal, it just happens to me. I can't help it. –you interrupted me-
- I know, and it's a natural feeling. But being a nice guy as you are, you must have been through this before. I'm sure I'm not the first girl to come to your place.
- Well, no. There have been two before you.

Poor thing! It was clear that you were by far no expert on women. You probably thought that we were the most confusing beings on the planet.

- I'm not asking you for details about your personal life. A start is all you need, so just let things happen naturally and I promise I won't bite you.

That made you smile. I drank my whiskey in one gulp.

- I just try to lead a hedonistic lifestyle. –you said-
- And who doesn't? It's fine to live your life based on taking pleasure as and when you feel like it, provided that you would do no harm to others in your pursuit of happiness. Yesterday is history and tomorrow's a mystery.

- It's what you do in the moment what counts. Isn't it your philosophy of life? —I asked-
- That's right.
- Ok, don't worry. Be happy, then.

My funny diarrheic verbosity was getting incoherent and you noticed it. I sounded as if I was under the effects of amphetamines and excessive sleep deprivation at the same time. And here was my grand finale:
- Oh oh by the way, may I ask you a question? —I said-
- Go ahead —you answered-
- I've uselessly tried to start your momentum towards... hmmm... say... excitement with innocent foreplay, but your reaction tells me that you probably prefer to either go straight to the point, so ... in that case I won't beat around the bush... or ... forget about it if you're not willing, because you may think I'm ugly or silly or...
- I think you're very attractive and clever.
- Oh, thanks. That's very kind. As I was saying... otherwise ...
- Please, get to the point. What is it you wanted to ask me? —you asked, impatiently-
- Ok, ok. Are you going to take your pants off, or am I?

What an unforgivable lack of social and sexual etiquette! I have no excuse. To my misfortune I've always had a sharp tongue and that night I was uninhibited, talkative and cheeky.

In Spain you would have cracked up with laughter at my silly antic, but in Burdishland things worked quite differently. I wondered how long it would take you to digest my insolent joke. I never behave like that but being under the effects of two shots of Scotch, anything could happen. You drank up your whiskey to lubricate your confidence.

I realised that my alcoholic wit had gone too far. Silence was only broken by the lava lamp blobs of wax ascending and falling like a fountain. My mind was working at the speed of the light trying to find topics to start a new conversation and move forward to some direction. But you continued to stare at me, laughing at the pants question.

- Did you know that you're totally and completely nuts? –you asked me slowly-
- Yeah. People tell me often that I'm so wacky... –I giggled-

Good thing my sense of comedy made you laugh. I liked the way you approached life's ambiguities with sophistication and humour, burying emotions. Spanish humour is the result of a mix of sarcasm, irony and exaggeration, being sometimes grotesque. Our cultural heritages clashed, of course. But I always ended up thinking "Vive la difference!".

- Now seriously, it's 2 a.m. Maybe it's still early for you, but in the UK bedtime's long been past. You may want to sleep on the couch or if you prefer... –you asked-
- What? –I asked, teasing you with a flashing coquettish glance

- You can... sleep with me in my bed if you wish –you said, looking down-
- I thought you were never going to ask me.
- I had to give you the choice. – you said, slowly blushing-
- I don't want to sleep on the couch, Ian. I want to sleep with you.

I was melting inside. As I made my choice, I threw my arms around your neck. I gave you a sly wink and said nothing more. Surprisingly you held me within your arms and kissed me until I had sore lips. I moaned in pleasure. Then, you held my hand and took me to your bedroom.

Chapter 35: The Burdish soul

You may have forgotten what happened between us in your bed that night. I wouldn't be surprised if you couldn't even remember my face and name.

Over the years my eidetic memory has allowed me to recall images, sounds or objects of my past with extreme precision. I'm not going to write down a quick refresher of that night for you. I'll keep it to myself. Let me just say that there's not a word of truth in the rumor that Burdish men are lousy lovers -although perhaps not the most romantic of lovers-.

- Do you think that Jack will still be waiting for me? —I asked after we had made love for the third time-

We looked at each other and laughed.

- Gosh, what a bad little woman you are. You're evil! —you said-
- He thinks I'm still a little girl. He's taking me to watch a pantomime tomorrow.

You nearly split your sides laughing.

- Really? That's for little kids! —you said-
- I know.
- He thinks I'm a small kid too. Some days before you arrived, he asked me if I had condoms. His question shocked me. I said to him, "Jack, we're in 1992 and I'm 30!".

- And then you bought a box of "Mates".
- I already had one.
- Uh Oh! Casanova spoke! I bet they had expired
- Nope.
- Yep. And when you knew I was coming over, you rushed to the gas station to get 3 12-packs.

You laughed loudly.
- I hope I haven't expired yet –you said, seriously-
- No you haven't –I replied, smiling at you-

Wow! Fishing for compliments and tooting your own horn at the same time! You talked about Juliette Binoche –your beautiful French muse-, Ken Loach's hyperrealistic films, your trip to Russia, the Glástnost, the Perestroika and the end of the Cold War. I always followed, eager to show you that I was interesting, educated, thoughtful and appreciative too, and if not intellectual then at least intelligent. But my dumb stories, jokes, and other random crap that I often used in these situations were not suitable for you. How come with almost opposite personalities we were yet so attracted to each other? How could our mutual fascination for each other possibly survive for more than 2 years?

You avoided by all means offering me a candid and totally prejudiced look at the Burdish stereotype, gladly proclaiming your open-mindedness and non-judgemental attitude towards others.

You proudly marketed yourself as an unconventional man, a nonconformist, a rebel. Your description was right, but incomplete. You were also introspective, insecure, reserved, unambitious, passionless and inhibited. Comparing you to the so-well-known-abroad standard notion of Burdish, I found a number of similarities.

You did everything possible to prevent what you hated most: making a fool of yourself. For that reason I guess that compliments, flirtation, romance and official dates were set aside. And subsequently, you wouldn't show your feelings –if they ever existed- until you would be completely sure that they were mutual.

There was something that didn't cease to amaze me: your excellent command of understatement. You were very good at expressing ideas with less emphasis or in a lesser degree than was actually meant. Coming from a country where people seldom use euphemisms in their everyday conversations and express their emotions with their voices, faces and bodies, it was fun to hear that

- Burdish never die; they pass away.
- Burdish don't tell lies; they're just economical with the truth.
- Burdish are not stingy; they're efficient administrators.
- Burdish are never unemployed; they're between jobs.

That was the height of political correctness! As I said before, you were a master of understatement and to my surprise, you even understated me!

Why you deliberately avoided calling me by my name is still a mystery to me. You never used a nickname or a pet name, least of all terms of endearment: a simple "you" sufficed. Was it a kind of shyness or an attempt to avoid a level of intimacy that you would be uncomfortable with?

Whatever it was, I realised that you were reluctant to take a personal approach, so our much desired relationship progressed at an exasperating tortoise pace. But hey, I had already set foot in your bedroom and that was a big success for a Spanish girl in the land of the stiff upper lip!

Chapter 36: Theater and tequilas

Nothing was said about staying together, so the day after, I went back to Jack's house. As I wrote before, he was inviting me to watch "Dick Whittington and his cat" at The Old Vic. I was very impressed to learn that the theatre was more than 200 years old and the longest continuously-running theatre in Burdishland. In these days it hadn't been yet rebuilt.

We sat in the nosebleed section, high above the scenario. We were surrounded by children that laughed aloud and bursted into applause every time Dick's cat appeared on the stage. It was an enjoyable experience.

That afternoon you were meeting your band at the rehearsal studio, but you promised to treat me to dinner in the evening. Jack didn't ask. At 6,15 p.m. you knocked at his door.

- Hi there. Sorry for being late. I got stuck at a traffic jam. —you said-
- Hi Ian. —said Jack drily-
- How was the panto? —you asked giggling-
- It was fine! I liked it! —I answered-
- Cool. Maybe I should take you to the playground instead of to a restaurant for dinner.

We laughed.

Before leaving Jack took me to the kitchen for a short face-to-face chat. He said he was angry with you for not being punctual and not dressing properly for the occasion, meaning that you had to wear a jacket instead of an old sweatshirt and jeans.

- Don't be so old fashioned, we're in 1992! –I whispered, fearing that you would hear the conversation-

Inadvertently, I repeated the sentence you had used when he warned you about buying condoms before I arrived. That reinforced my conviction that he was definitely well behind the times.

- He should have brought you a bunch of flowers. –he added, harshly-
- Come on, flowers are too formal and too cliché! If he ever did, I would die of shame! –I said-
- Flowers have always been a classic gift for a woman!
- But not on our second date! I guess too much time has passed since you last courted a woman!

I had been extremely rude to him out of anger and I regretted it immediately. But I was frightened by his excessive emotional reaction against you. I ran away from him to take shelter next to you.

- Are you ready? –you asked-
- I'm ready and willing. –I answered-
- Fine. Let's go then.
- I'll stay at Ian's place tonight, Jack. So don't wait for me. –I said-

- That's fine. Go and have fun. —he said before shutting the door -

You noticed something fishy. It would have been very embarrassing to tell you the truth so I pretended nothing had happened.
- Is everything okay? —you asked-
- Yeah, everything's fine. —I answered to reassure you-

We drove downtown in your second hand 1985 Nissan Bluebird. I remember jumping down stairs beside you by the General Hospital, rushing for fun downtown, heading to the lively atmosphere of White Ladies' Road where hundreds of happy people danced in the clubs, drank at the pubs and had a lot of fun.

We had dinner at a Mexican restaurant called "Los Iguanas" that claimed to "conjure delicious, authentic South American food, made with passion, love and lots of Latin magic". We had burrito pies, tacos, Coronitas and of course, tequilas and margaritas.

At 11 p.m. we walked to your place under the rain. There was a group of drunk teenage girls zigzagging about and singing loud. We elbowed our way through them.
- Thanks for saving my life. Who knows what they could have done to me. —you said, pretending to have escaped from a dangerous situation-

You made me laugh.

- Let me tell you a secret. I'm a bit squiffy on the tequilas. —I said to you-
- Don't worry. I won't tell anyone. Cross my heart!
- Keep this to yourself, OK?
- OK. No Scotch tonight, then.
- No, no Scotch.

I shook my head and smiled.
- ¿And what about a little bit of whoopee-making? —I asked you playfully batting my eyelashes-
- If you ask me… I won't say no.

After such a lively response I could just think: "Up with the spunky people!"

Chapter 37: The Russian wedding ring

The curtains were drawn across the windows. It was half past ten in the morning. I watched you sleep. Your gentle breathing was the only sound that interrupted the silence in the room. I snuggled up to you, to keep warm. When you woke up, you could hardly open your eyes. You put your arms around me not very enthusiastically. We quickly broke from our embrace and stood far apart. We were just two strangers waking up the morning after in the same bed, too shy and insecure to be romantic, so love tokens were not allowed.

- Good morning –you whispered-
- Good morning –I said, giving you a smile- Wow! Nice tousled hairstyle! –I said-
- Well, aren't you hilarious today? It's the result of bed head. –you said-
- Oh dear, and where's the Greek God I went to bed with last night? –I asked joking-

You laughed and threatened to spank me. Everything around us was a mess: a glass of pineapple juice on my night table, four used condoms and a pint of hot squash on yours. Our clothes were spread all over the carpet, thrown away in a rush. Your bedroom actually looked like Godzilla had thrown up all over it. It was easy to tell that we had gone without sex for a while.

Although it was cold, we quickly moved from each other's side, again afraid of exposure and rejection, before strange feelings would replace the memory of our wonderful days and nights.

- What time is it? –you asked-
- It's half past ten. – I answered after looking at my wristwatch-
- Oh shit! –you moaned-.
- What's the matter?
- I had to be at my parents' house half an hour ago.
- Uh Oh...

I bet they didn't expect you to show up before midday. We had a quick breakfast: a cup of tea and a couple of Weetabix slices floating on a milk sea.

You promised to be back at 1 p.m. To my surprise, I heard you lock the door as you left so I could find out for myself the hair-rising experience of being imprisoned while you were out. What would have happened if there was a fire, an earthquake, a nuclear war, a megatsunami, a meteorite impact or an alien invasion? Nothing much to worry about, as I could tell from your resolution to lock me in without any warning.

Outside it was pouring with rain. Montague Hill Street was deserted and so were Jamaica Street and the borders of St. Pauls. There was total silence except for the tapping of the raindrops on the window glass.

You came back at 1.30 p.m.

- Hi there! Sorry for being late, but the folks wouldn't let me go... – you said, as you opened the door-
- You locked me in! –I said, very annoyed-
- Well, hm, yes, I'm sorry but there have been some burglaries recently in this block and I'm a bit paranoid about it.
- You should have told me!
- I'm sorry.

How many times could you say "I'm sorry" and really mean it? Not many, I guess.
- You must be hungry. –you said, quickly changing the subject -
- I'm fine, thanks. –I said, still cross-
- Let's see what we have today for lunch... –you said opening the fridge- What about cheese filled cannelloni with tomato sauce? – you asked me, grabbing a box of frozen food-
- Sounds good. –I answered-
- Great. Five minutes and our meal will be ready.

You put the box in the microwave and set the timer. Five minutes later it beeped.
- Ooooo... maaagic! –you said, opening the microwave door and took the sizzling hot cannelloni, ready to be eaten, with a powerful rich smell that instantly filled the kitchen.

When the rain stopped, we went to Brandon Hill for a walk. It was sunny, but very windy and cold too.

- This country is disgusting in winter —you complained-

I put my hood on. Suddenly you stopped and looked at the ground. There was something round and shiny beside my feet. You took it and showed it to me.
- What is this? —I asked-
- It's a Russian wedding ring. It has three rings linked. They signify the Holy Trinity. Somebody must have lost it.

You put it in the palm of my hand.
- Keep it. It must be your size.

Surprisingly, it was.

You had given me a wedding ring as a symbol of love and devotion, or so I thought. But in reality you only had offered me something you had found on the ground. My twisted perceptions were far from reality. I saw what I wanted to see and heard what I wanted to hear, while you remained quiet, indifferent, avoiding carefully the red line that you didn't want to cross. And yet I didn't want to realize it.

We sat on a bench to enjoy the panoramic view of Bristol from the hill.

You spoke to me about docks and fishing boats, but I saw naval battles, shipwrecks, seamen and vessels sailing the seven seas. You talked about the sun and the clouded sky, but I pictured a universe of planets, galaxies and storms of falling stars. Bristol explained by the Bristolian. Metaphors imagined by the alien. You took me to the tower but I was already on top of the world.

The wind blew chilly and cold, but nothing would stop me from dreaming. I would fly my way back home wearing that Russian wedding ring, like a bride. I would tell the friendships it was the loving present of a handsome Burdish man, who was looking forward to seeing me again. I would even tell them facts were stronger than reality and show them the evidence of my childish happiness around my finger, just in case they wouldn't believe me and let them know that for once in my life, I was the princess of the tale.

I looked at the ring and rubbed it, feeling good on the inside. That triggered your concern. You stared at me seriously.

- Annie, there's something I want to tell you.

I knew the breakup was coming before we even had the chance to start.

- You're very nice and I like you, but I don't want to get involved. I'm happy to go out with you as friends, but I don't want to have a relationship. I enjoy your company and I think you have a lot going for you, but I don't want any commitment. –he said-

What a great excuse to avoid entanglement yet maintain a sexual relationship! It felt like the floor had dropped out from below me. I didn't know that it was just about sex instead of love. I should have seen it before.

Your last offer, if there was any, was a long distance friends-with-benefits relationship. But I couldn't accept that: I had already developed feelings for you. Being your bedmate until you would get bored of me? Why would I put myself through that torture? Someone had to smack me in the face asap and help me come to terms with reality.

I was heartbroken to find that I meant nothing to you. But I had to pull myself together, somehow. I had to get up and face you.

- Hey, cool your jets, ok? I don't want to have a long distance relationship either, so chill out. –I said, pretending I was fine.
- I didn't mean to be unkind, just wanted to put you in the picture.
- I know where I am, so no worries. –I replied, staring at you -

We had missed our one-in-a-million chance: harder to happen than a planet conjunction or a comet quietly crossing the sky. That Russian wedding ring was the saddest thing I ever owned.

No one else was in my thoughts but you. I hid my sadness behind a smile and did my best to keep it in my face pretending that nothing had happened after our conversation. You seemed to calm down. We passed Eugene Flats in silence. The charm was gone and the magic had slowly vanished.

When we arrived at your place, you prepared a cup of tea. We sat on the couch in embarrassed silence. You switched the TV on to watch old episodes of Star Trek. I felt very uncomfortable and after a while I decided it was time to go back to Jack's house.

- I must be going now. I'm leaving early tomorrow –I said-
- Yes, of course. I'll take you there –you said-
- Never mind. I'll take a taxi.
- No, I'll take you there. –you insisted-

You carried my bag and put it in the trunk. You added then a touch of Burdish humour with a trivial discussion about the differences between Burdish and Appalachian Spanglish which, according to you, was the dialect I spoke.

- We don't say "trunk" here. We say "boot". –you said-
- A boot is something you wear on your feet! –I emphasized-
- And a trunk is a part of a tree!

Teaching new tricks to an old dog never works. So I still say:
"apartment building" instead of "block of flats"
"bar" instead of "pub"
"cookies" instead of "biscuits",
"detour" instead of "diversion"
"elevator" instead of "lift"
"fries" instead of "chips"
"gas" instead of "petrol"
"highway " instead of "motorway",

"intersection" instead of "crossroads"

"jello" instead of "jelly"

"kerosene" instead of "paraffine"

"line" instead of "queue"

"movie" instead of "film",

"neighbor" instead of "neighbour"

"one way ticket" instead of "single ticket"

"pants" instead of "trousers"

"railroad" instead of "railway"

"subway" instead of "tube"

"trunk" instead of "boot",

"undershirt" instead of "vest"

"vacation" instead of "holiday"

"windshield wiper" instead of "windscreen wiper"

"zipper" instead of "zip"

Regretfully, achieving fluency in Burdish language and being successful with Burdish men are two lessons I'll never learn.

Chapter 38: Leaving Bristol

As soon as you dropped me at Jack's house, he asked for a summary of the situation.
- Hey, how did it go? –he said, eager to know-

I sighed and smiled sadly.
- It didn't work, Jack. I really like him but it didn't work.–I answered-
- Oh my, now I understand why you looked so sad when you kissed him goodbye! –he said, putting his hands above his head- What happened?
- He said that he likes me and that he's happy to go out as friends, but he doesn't want to get involved. So I give up on him.

Jack sat on the armchair and shook his head with disapproval.
- He's an absolute dead loss! –he groaned -. He's still a kid at heart, and you are a mature person!
- Go deal with someone who can appreciate what hard work and commitment can do for a relationship. You deserve better than that! –he said-
- Jack, he's entitled not to fall in love with me. –I said-
- But he's not entitled to play with your feelings! As far as I'm concerned our friendship is over, and I'll let him know first thing tomorrow!

- Don't do that, please. I'll feel real bad if you break up with him. That will bring you a lot of sorrow and you will regret it if you do. Don't be so hard on him.
- I'm old enough and wise enough to know what is best for me. The only regret I have is that I've dragged you here.
- Jack was outraged and I was inconsolable.

I left Bristol the morning after at 8.30 A.M. It was wet and dark, and my sadness grew deeper as the coach left behind places where we had been just the night before. I was on my way to Heathrow and couldn't hold back my tears. In a few hours I would be flying home and you would be back to the hateful routine of another working day.

I wrote a thank-you card from the airport to show gratitude for your hospitality. Regardless of whether our romance was alive or not it wouldn't hurt to be polite. If my memory serves me well, the card had the picture of a happy fat cat smiling from an orange background. That would prevent me from sounding pathetic or enraged if I disappeared forever.

"Up with the hedonistic lifestyle!" – I wrote -.

I couldn't help being sarcastic. It was the lowest form of wit, but also my natural defense against you.

At the airport, a P.A. announcement was repeated over and over: "For security reasons, baggage left unattended will be removed and destroyed."

I was stopped at the security check-in, taken to a separate aisle and frisked. How I wished the Burdish police would find my emotional baggage, remove the burden from my shoulders and eventually destroy it!

Chapter 39: Things I've never told you

I do own one of those heart things, so I kept thinking about you. My memories were blurred images of the North Somerset landscape from your car, while you drove from Glastonbury to Cheltenham and then to Bath.

I still remember when you rescued me from a crowd of Japanese tourists, while you carried my shopping bags under the rain. When you dared ask me how old I was and when was my birthday. When you blushed at the antiques shop, when the old storekeeper asked me "Are you married?" and in the meantime you pretended not to listen, having a look at a collection of silver spoons and I answered "No, madam... we're just friends".

Three years later I was told that you continued drinking with your friends until it was late at night on the week-ends. Nothing seemed to have changed at all; perhaps just a soft foreign breeze under your duvet at the very beginning of the year; something not really worth to remember.

Jack told me that your dad was a big shot at Solsbury's Bank. He was so tired of waiting that you would decide to get off your butt and look for a job, that he offered you a position in sales at the bank's insurance department. In these days you would have done everything for the sake of money to keep your independence, even falling under dad's control again. It was annoying having to get up at 7 a.m., dressing up like a penguin, looking like an idiot and working 8 hours a day for peanuts!

From then on, Jack carefully avoided mentioning you. He flew over to Spain a couple of times and I showed him around. I guess he felt obliged to correspond and he invited me to visit Bristol again in 1994. I was still unable to see that I had been your plaything and some months later, I bought an air ticket to Bristol. I made a huge mistake: phoning you to let you know about my trip and ask if you'd like to hang out with me when I was there.

- That's very nice of you but you can't stay in my flat because I'll be working –you said, extremely serious-

Your answer made me feel very embarrassed. You thought that I was putting you on the spot for my own self-invitation but nothing could be further from the truth.

- I never asked you if I could stay in your flat -I asked, very upset-
- I just had to let you know so that you can organise yourself.
- I'm visiting Jack and I'm staying at his place. I'm not going to Bristol to see you, Ian. Don't be so vain –I said, quite upset-
- I'm just telling you that we can't be together because I'll be working during the week.
- I've just told you that I'm not going to Bristol just to see you. Do you understand what I'm saying? –I shouted coarsely, real cross-

You know the rest. I put the phone down and never caught that plane. I had swept my feelings under the rug and put on a happy face for the world. It was time to accept that it was really over. Jack was very disappointed to hear that your response made me cancel the trip.

- I lost it. I couldn't stand his polite way to say rude things—I said-
- If you come over, you don't even have to see him.
- I know. But what's done is done.
- Listen Annie, how much did you spend in that air ticket?
- Why do you ask?
- Because I'll send you the money you've lost.
- No way! I'm the one who cancelled the trip, so tough shit. Thank you just the same.
- He made you cancel the trip.
- I don't want to hear about him anymore, Jack. As far as I'm concerned, he's a write-off. Period.

And I put the telephone down.

Chapter 40: I was not supposed to know

That fatal Sunday, 17th February 1997, I tried to reach Jack on the phone a zillion times without success. That evening an unknown voice answered:

- Hello?
- Could I speak to Jack, please? –I asked-
- Who's calling?
- It's Annie Martin. I'm calling from Madrid. I… always phone him on Sunday evenings to chat a bit.–I said-
- Oh yes, you're the Spanish girl! He told me about you. This is Lou Vasilopoulos. I've been his neighbor next door for five years until my wife and I moved to the suburbs.

Jack lived on his own. I had a very bad feeling as I asked myself why on earth that talkative guy was answering my phone call.

- I'm sorry, but I'm afraid you won't be able to speak to him… unfortunately Jack passed away last Thursday. –he answered-
- What???
- He had a sudden heart attack. I'm very sorry to bring you such bad news.

I was in shock. I couldn't believe that Jack had died. He was only sixty two. He just ate organic vegetables grown in his allotment.

He went to the swimming pool three times per week and always walked downtown instead of taking the bus. He was so full of life just one week ago! How come he had died?

Lou Vasilopoulos was a thirty three gorgeous dark haired man who had emigrated from Greece to Burdishland with his family when he was a small kid. His father owned a very prosperous car rental business and the whole family worked there. I was not supposed to know, but he had cheated on Amanda, his beautiful Burdish wife, five years before. When his burden of guilt felt too heavy, he confessed his sin. They nearly divorced after that, but in the end she forgave him. Jack told me and he made me promise that I would never unveil the secret.

Lou said that the funeral would be the next Monday at 11am at St. Mary Whitecliffe. On Saturday morning, I flew to Burdishland and took a coach from Heathrow to Bristol. I had a lot of time to think during the three hours I spent caught in the M-4 traffic jam. Lou picked me up at the National Express coach station and due to the circumstances he kindly offered me to stay at his house. I accepted, even though ever since our last incident, Burdish hospitality scared the hell out of me.

Chapter 41: You again

I hadn't heard from you for 2 years. It was a bit embarrassing to meet again at Jack's house after our stormy breakup, but you were so sweet and friendly that I couldn't help remembering our happy days together. You told me you were still working as a clerk at Solsbury's Bank. You explained to me how much you hated that job, because everybody knew that you had good connections and you hated owing your father a favor.

I was not supposed to know, but you were still emotionally damaged by an incident that deeply marked your life: you got your girlfriend pregnant at the University and she had an abortion without telling you. She said it was her right; you said you felt betrayed and angry. And yet Jack developed his best matchmaking strategy ever, so that you and I would become Bristol's Romance of the Year. It was nice while it lasted. But just in case I still kept my hopes up high about us, you repeated like a broken record "now that I have a relationship…"

Chapter 42: Gayle

I attended a Protestant funeral for the first time in my whole life on Monday 25th February 1997, hoping it was the last one. I had no particular reason to think that, other than not being much of a churchgoer and not really feeling in my element at religious gatherings. But this time the ceremony was warmer and less formal than a Catholic one. The priest in charge welcomed and greeted those present as they entered the chapel, shaking their hands with a smile.

In the church, I saw a small black woman in deep mourning crying her heart out, alone on the last pew. There was a young boy of around twelve years old comforting her. I was not supposed to know, but she was Gayle, Jack's lover, and the boy was Brian, her son. She was a school teacher in St. Peter's and met Jack when he worked as a meter reader for the electric company.

Jack was single. He confessed to me that he had some torrid affairs with horny housewives on his work route, but Gayle was different. She was very honest and passionate, but most importantly: she was a good person. He fell madly in love with her. They used to meet on Thursday evenings, when he was supposed to be on duty, but he spent the night with her instead. He used to speak in code, referring to her as his "Black Thursday" because that was the day when he met her. But of course, I was not supposed to know.

I handed her a pack of tissues. She accepted them giving me a grateful smile and whispering "thank you".

She looked at the Spanish brand name written on the pack and then asked:

- Are you the Spanish girl?
- Yes. My name is Anna. And you must be Gayle, right?
- Right.
- Jack told me about you.
- He told me about you too. This is my son, Brian.
- Hello Brian.
- Nice to meet you, madam.

The kid looked sad too. He and Jack got along very well. You called me. I asked myself to what did I owe that honor.

- Annie, my parents would like to say hello to you. Do you think you could join us over there in our pew? —you asked-
- Sure —I said, nodding-
- Thanks —you said, kissing my cheek-

Before I went, Gayle grabbed my arm and whispered in my ear:

- Can you spare me some minutes after the funeral to talk about an important matter? —she asked-
- Sure. I'll meet you then. —I said-

I waved goodbye to her and walked towards your mom and dad, wondering what on earth could be so important.

Chapter 43: Mom and dad

Still intrigued about Gayle´s request for talk and under the effects of your strange affection displays, I followed you to say hello to your parents, Caroline and John. I was not supposed to know that they hated each other cordially, though they kept up appearances. Caroline was amazingly cunning and didn't usually get owt for nowt: if ever John wanted to have sex with her, she always asked for something in return; a jewel; a fur coat; a new purse; anything, as long as it was expensive. Otherwise, there was no deal. John realized that it would be much cheaper and a lot more pleasant to have a mistress, so as soon as he found one his bank account quickly went back to black. According to Jack, marriage was actually a prostitution contract, and the Logans were the living proof of it. But of course, I was not supposed to know.

I knew you were the youngest of the family and a much-wanted baby boy after three girls. Your sisters married well, and I was not supposed to know, but they kept me under close scrutiny, just in case their beloved youngest brother would feel tempted to get involved with a daughter of the Kingdom of Spain, that banana republic in the south of Europe. My memory cleans up efficiently what I don't want to remember, so I quickly managed to delete them from my hard drive.

You looked set to become an old batchelor. Everything your mother wanted was to find a victim to get her lumbered with the beaut.

When she knew from Jack that we had spent a week together, she spotted me as the ideal candidate and started writing me deeply felt letters in which she told me how miserable you were. But the truth is you were not miserable at all. That was just Caroline's trick not to lose track of me. She was immune to discouragement and not easily dismayed.

I was not supposed to know that you were dating secretly a French au-pair girl from Bath and you were having a hell of a good time.

- Hello sweety, it's so nice to see you again! How's everything in Madrid? –she asked, overdoing the smile-.
- Caroline! Everything is fine! I'm glad to see you too –I answered-.
- You look great!
- That's just because you're used to see me always in jeans! By the way, you do look really elegant!

We both laughed, as if we had always been good friends. She told me they had moved to a bigger house, right in front of The Downs and wrote her address in a piece of paper that she handed me, just in case someday I would be back in Bristol.

- Please, don't forget to visit us.
- I promise I won't. -I said to her, as you looked at the scene, quite worried-.

But fear not. Nothing could be further from my intention.

Chapter 44: Gayle's secret

You asked me if I would be attending the after funeral reception at Jack's house in the afternoon.

- Yes, for a last goodbye. –I answered-
- Some of us will be meeting at 7 p.m. at The Artichoke to have some pints. NOW THAT I HAVE A RELATIONSHIP I shouldn't be asking you out –you said, giggling- But… would you like to join us?

I was getting tired of dealing with these unwanted remarks about your new relationship.

- Hey. Take a chill pill dude, ok? I promise not to bite you. Bring your girlfriend to the pub. I won't bite her either.
- She's in France visiting her parents.
- Oooh, what an awful shame! –I said striking back-

I was not in the least interested in the details, so I excused myself and left to speak to Gayle, who was waiting for me, still sitting on her pew.

- What is it you wanted to tell me, Gayle? –I asked her-

She approached me and whispered in my ear:

- Jack didn't die from a heart attack. He killed himself.

OMG! I WAS NOT SUPPOSED TO KNOW!

- What? Why would he do that? – I asked in shock-
- Because he wanted to marry me. Of course, his family didn't approve of that: a colored Jamaican single mother who lives in St. Pauls is not exactly a good catch.
- Excuse me but knowing Jack it's hard for me to believe that he killed himself for that reason. He was a very lively and courageous man.
- They made his life hell with threatens, insults and mockeries and he fell in bad depression. Jack gave me Edward's e-mail address and asked me to use it only if I didn't hear from him again.
- I was so alarmed when this ordeal started that I e-mailed Edward explaining him that I feared Jack could inflict serious damage on himself... you know what I mean.
- And what did Edward say?
- He never answered. It's pretty obvious that he didn't take any notice of what I was saying. He hates me. They all hate me. Last week Jack was found dead in the bathtub. He had slashed his wrists.

I could imagine her desperation. She was crying tears of rage and hatred.

- So the relatives decided to keep it secret. Who else knows this? –I asked-
- Only Edward and Lou. Lou is the one who told me. –she answered-

I began to think that Lou spoke too much. Was it really necessary to tell Gayle the naked truth and make her suffer even more?

- I'm deeply impressed. I don't know what to say. His sudden death makes me real sad and I'm very sorry that it all went this way.
- Jack did more than I had ever expected for Brian and me. His last will and testament mentions Brian and me. He left to Brian all his savings for his education.
- That's a nice act of love.
- Indeed.
- I wish I could do something for you.
- You've listened to my biggest sorrows. This is more than anyone else has done for me today.
- Your secret is safe. Sometimes it's easier to be honest to a stranger. Discretion is guaranteed. I just hope the chat helped you carry this heavy burden for a little while.

I held her hand and whispered in her ear:

- Please accept my advice: don't waste your time and energy hating them. It won't take you anywhere and you'll get bitter. Keep the good memories of Jack in your mind. I'm sorry to have met you in these circumstances and I really hope that you can rebuild your life.

We hugged for a long time and I shared her pain and her intimate drama. But of course, I was not supposed to know.

Chapter 45: The after-funeral reception

The appointment was at 4 p.m. Lou's wife had prepared cucumber sandwiches and hot tea for up to 25 mourners. Some of us had travelled a distance. Jack's best friend arrived from Holland. There was also a cousin from Cornwall and a close friend from Saskatchewan, in Canada.

I was not supposed to know, but Jack's sister-in-law had been a manic depressive all his life. Now they call it bipolar disorder. She and Jack were not on good terms, but surprisingly, she was crying a river that day. The family portrait was completed with Edward - magnificent, arrogant older brother-, acting as proud toastmaster, beside his submissive wife. Some pictures of Jack were hanging on the walls of the living room, where the cucumber sandwiches and the hot tea were disappearing fast. They were not supposed to know, but I hate cucumber sandwiches.

Soon everybody moved to the pub: The Italian teacher, the Dutch friend, the Japanese classmate, the Canadian cousin, the Burdish gang and me, the señorita -as I heard someone call me-. I always love to mingle with the natives.

We all met at The Artichoke at 7 p.m. It looked a pseudo-trendy place outside, but in reality it was a traditional Burdish pub. Don't look for it in the pub guides now. You won't find it. It was demolished years ago to make way for a hotel. But of course, we were not supposed to know.

We talked about music, work, food, politics, religion… about everything except ourselves. And just in case I hadn't got the message, you repeated your tedious mantra over and over, rubbing it in my face:

"I'm quite happy, NOW THAT I HAVE A RELATIONSHIP*"*

"I'm not supposed to be here, NOW THAT I HAVE A RELATIONSHIP*"*

"I feel like a whole new man, NOW THAT I HAVE A RELATIONSHIP*"*

"Good for you!" was all I could say.

Despite the irritating reiterations about your new sentimental status, I gave you my telephone number and address. One never knew if life would turn the tables and bring us back together again someday.

Apart from that, there were pints, laughs, chips, popcorn, music and fun. And we all honored the memory of our good friend Jack. He would have really loved to join us… but he was not supposed to know.

Chapter 46: Untimely, as usual

Why on earth couldn't we be together without any fuss, Ian? It took me years to erase you again from my memory and yet you're back. I learned the hard way what a waste of time "on & offs" are. Good relationships don't work that way.

Years passed and I realized that trying to be friends after breakups was impossible. Then and only then, I could definitely delete you from my mind. But even when we dated other people, after spending these years as human yo-yos, there was a cosmic attachment between us that we couldn't get rid of.

In February 1998, one year after my last visit to Bristol, I received a heartfelt letter from your mother.

"Dearest Annie,

I hope this letter finds you and your family in good health. I have big news to tell you: Ian has got a job as an English language teacher in Madrid. I didn't know how in demand native English teachers are! We visited Ian last month. The language school didn't help him find accommodation but he is sharing flats with some colleagues. They say Madrid is a city always bursting with vitality, but I found it rather sad and gloomy. I thought you may like to get in touch with Ian and maybe ask him out. He feels quite lonely and would be very glad to hearing from you. These are his address and telephone number: XXXXXX

Best regards,

Caroline Logan."

After reading the letter, I felt absolutely gobsmacked.

I realize that when you're in a new country it can be hard to connect with new people and make friends but, hadn't you learned anything whatsoever from all the previous times in those eight long years that we rode our break-up-and-get-together-again merry-go-round? How many times were we going to split up?

I understood your mom's worries too but, perhaps you should have told her that you were a grown man, don't you think? I guess that she suggested you to call on me, but you refused to do so and she decided to take fast action.

At that moment I was dating a guy I had known at work and I really liked him. I felt special, loved and cared. I found the inner peace I had been searching for and you had completely disappeared from my horizon.

Out of politeness, I should have answered your mom but I didn't want to stir up old memories. As I didn't, my guess is that she probably pushed you to get in touch with me directly. Nine months later you plucked up courage and decided that I was your last resort in a hostile city where you neither spoke the language nor enjoyed yourself.

At the beginning of November, 1998 I found in my mailbox this brief letter:

"*Hi Annie,*

I'm working in Madrid as an English teacher. I called you on the phone some months ago but I couldn't get through to you. I think I got the wrong number.

Just in case you'd like to get in touch, here's my phone number: XXXXXXXX. Maybe we could hang out, go to the cinema etc.

Best regards,
Ian."

You were late, as usual. I asked myself how you could possibly take such a passive approach to life and relationships. Your letter was untimely and extremely inconvenient: it reached me exactly two weeks before my wedding. Given my situation, I considered that the best thing I could do was ignoring you. It's not my style to behave that way but I didn't need to complicate my life more than necessary. So I never phoned you. The "Ian saga" had to be definitely finished.

I'm a married woman now, a mother, a daughter, a sister, a niece.
I'm a school teacher, a nurse, a driver, a cook, a dressmaker, a psychologist, a cleaning lady.
I'm a lover, a sinner, a slut, a porn actress, an adventurer, a creative author.
I'm a singer, a sleepless writer, a clown, a sorceress, a comedienne.
I'm a hard worker, a tireless fighter, a nice colleague, sometimes a bitch, sometimes an angel. I found out what I wanted to be and don't want to be anything else.

Just to put you in the picture.

Chapter 47: Surfing the net

In 2010, reminiscing on some old memories, I couldn't resist the temptation of googling you and I got some interesting results: your first band —Tea & Norbert Lemons- had uploaded to Youtube several clips from your 1992 gigs at the Uniun Night Club. There were also some messages left in your channel.

- Am I too old as I approach 40 to aspire to be in a band like this? – asked someone called Bobby M.-

The drummist, who appeared to be a joker, answered the questions in humorous vein:

- No. Most of the musicians in this clip are now over 40 and still aspiring to be in a band like this!

The guy sounded nice and I knew he would give me the information I was interested on:

- Are the T & N.L. still alive and kicking? What are they up to now?

He answered immediately:

- The T & N.L. split into two halves both of which are still active and Youtube search will reveal all:

 Bassist and guitarist on left: The Carbohydrate Manual
 Singer and guitarist on right: The Deltas

I searched again as recommended and found out that you and your new band, The Deltas, were immortalised in Youtube. You even had a website and a page at Myspace! What a shocker!

I had a look at the pics. It was really funny: 20 years after you still combed your hair in a quiff receding into shorter hair at the back with a trimmed back and sides, in the most genuine rockabilly style. And thanks to the information technologies I could buy your albums, watch your videos on Youtube and see by myself that The Deltas were a celebrity among the local bands.

That was fine, but curiosity was driving me beyond nuts and I had to scratch the itch of my unbearable impulse to find more information about you. I looked for your address and phone number. And I found them. The phone listing revealed as well that you now shared flats with someone called Grace l. Logan. Great. It seemed you had finally found your best half. I could have gone further, but I decided to put an end to the search.

I felt like a moth that got himself too close to the light.

Chapter 48: Splendor in the grass

This story is not about love and romance.
It's about loss of innocence and growing old.
It's about the passage of time through our lives, ephemeral and fast like sand inside a watch, here today and gone tomorrow.

About irrevocable changes.
About losing our expectations, our emotions, our hopes and dreams, our passions and our will to take the world by storm.
About changing the way we were, about losing a significant part of our vital energy and the belief that love would last forever and save us all.

About realising that everything comes to an end.

And to sum up, it's about something that could have been but never was; because time changes everything.

Very few things hurt more than that.

Ode: Intimations of Immortality

What though the radiance which was once so bright
Be now for ever taken from my sight,
Though nothing can bring back the hour
Of splendor in the grass, of glory in the flower;
We will grieve not, rather find
Strength in what remains behind...[14]

[14] William Wordsworth 1770 – 1850 (from "Recollections of early childhood")

www.ingramcontent.com/pod-product-compliance
Lightning Source LLC
Chambersburg PA
CBHW070230180526
45158CB00001BA/276